DEDICATED TO THE CULTURE"

The Art of Sneakers | Volume One
Copyright © 2019 by Ivan Dudynsky

Follow us on Instagram and Facebook at: @theartofsneakers

Presented and produced by snkrINC
Follow us on Instagram and Facebook at: @snkrinc
www.snkrinc.com
snkrINC
1926 East Maple Ave
El Segundo, California 90245

Published in the United States by powerHouse Books,
A division of powerhouse Cultural Entertainment, Inc.
32 Adams Street, Brooklyn, NY 11201-1021
e-mail info: info@powerHouseBooks.com
website: www.powerHouseBooks.com

Designed by Alec DeMarco, Buzz Chatman, Christophe Roberts, Frank Kirstein and
Ivan Dudynsky

Grateful acknowledgement is made for permission to reprint the following artists work:
Jeff Staple, Frank Kirstein, Jeff Cole, Alec DeMarco, Freehand Profit, Honorroller, Cesar
Idrobo, Kenr0ck, Kickstradomis, Laro Lagosta, McFlyy, Christopher Mineses, Steph Morris, Ro,
Christophe Roberts, Stomperhaus, Toygami, Tracy Tubera, Park Tyson, Tom Yoo and Mimi Yoon.

Library of Congress Control Number: 2019948780

ISBN: 978-1-57687-955-9

Printed by Friesens Corp.
10 9 8 7 6 5 4 3 2 1

First edition, 2019
Printed and bound in Canada

THE ART OF SNEAKERS
VOLUME ONE

Compiled by
IVAN DUDYNSKY

powerHouse Books
Brooklyn, NY

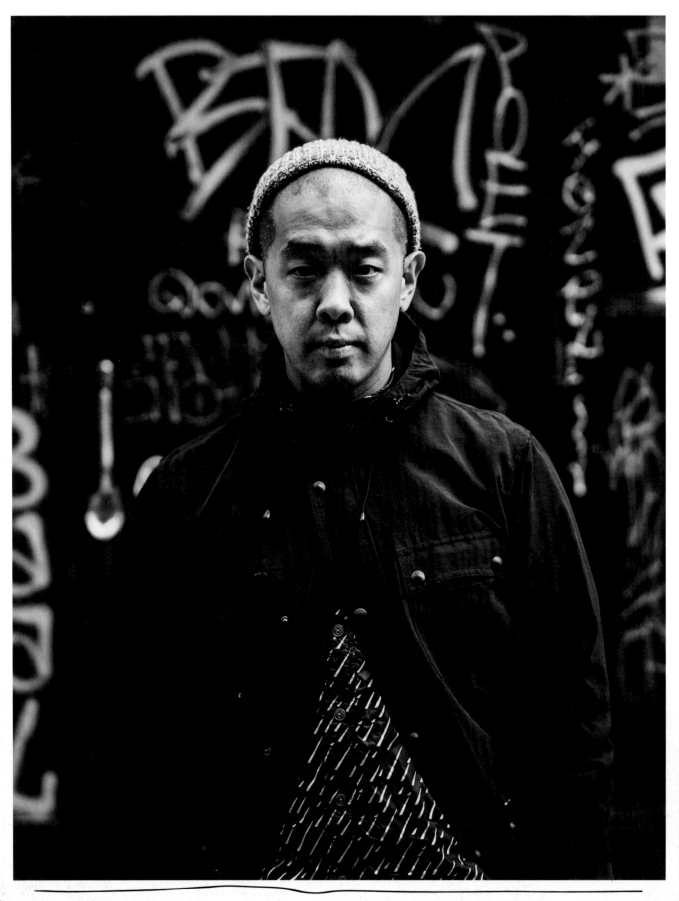

JEFF STAPLE

They say beauty is in the eye of the beholder. And one person's passion is another person's trash.

Case in point:
To one, a sneaker is a common household item. A thing one wears to the gym. A thing one steps in dog shit with. A thing that is made to be used, destroyed, tossed, and then replaced—one pair at a time. To others (probably to you I'm guessing?) the sneaker is quite simply a piece of art. And why shouldn't it be? Try to name another item that combines sport, technology, innovation, design, and fashion—all mushed into one 12-inch piece of rubber, nylon, and leather. That sounds like some high-concept art to me! Now, factor in other ancillary aspects like filmmaking (Space Jam, "It's Gotta Be the Shoes"); music (MY ADIDAS!!); finance (StockX); and community (snkrINC).

It's truly difficult to find a single object that encompasses this much depth and substance. Yet, at the same exact time, the sneaker is extremely democratic. Most people don't go around walking barefoot. So shoes are a necessary part of everyday life.

Universally everyone can understand the concept of putting on a pair of shoes. Adding to that, is the fact that sneakers are priced within reach for most people to obtain. Forgetting resell prices for a moment, a sneaker is conceptual high art that everyone can take part in. Therefore, it really only makes sense that a whole new generation of creatives are now paying homage to the art of the sneaker with THE ART OF SNEAKERS!!!

In fact a whole entire subculture has risen out of the passion for sneakers squarely dedicated to making artwork as an homage to shoes.

Here's the really interesting thing though: these creatives don't actually design shoes from scratch, they don't sell shoes, and they're not the athletes who perform in the shoes.

THE SNEAKER IS THEIR MUSE, A SOURCE OF INSPIRATION TO EXPRESS THEMSELVES CREATIVELY.

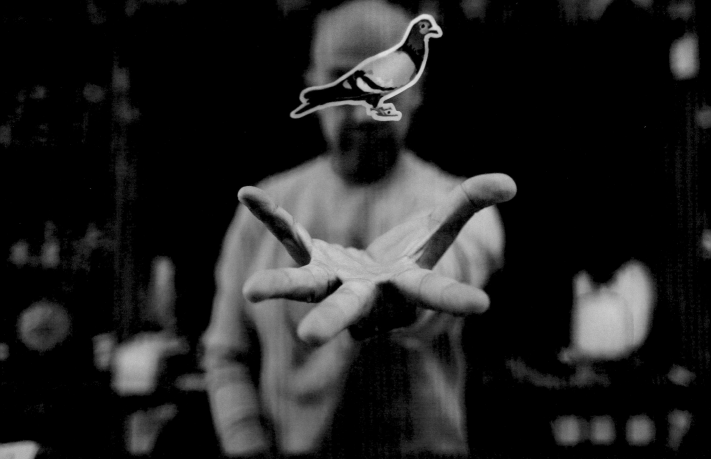

And remember...to some people that just sounds crazy. Imagine being inspired by toilet paper or car tires to create art? To some people, sneakers, toilet paper, and car tires are in the same category! The work these individuals create is amazing. The various processes used are wide and varied. We're talking paint, pencil, origami, Legos, spraypaint, food, manga, leather, masks, digital photo manipulation, cardboard, and so much more. You'll see the beauty and variety laid out in the pages here.

Being inspired by sneakers is incredible.
But even more powerful than that?

It's the fact that these works of art now come full
circle and inspire the work of actual footwear designers at
sneaker companies. And furthermore, the works of art
inspire others to push the envelope even further.

I've been in the sneaker industry for 20-plus years now. And I've been a true sneakerhead since the 6th grade. Every few years, I ask myself, "Jeff, when will you grow out of this?" Now that I am wiser (i.e. old), I realize I will never outgrow sneakers.

This has gone beyond a fleeting trend for me. It is a staple of my soul. It's a necessity. A means of transport. An expression of style. A nod to my art, my roots, and my DNA. God, I hope I will never grow out of it. And I hope artists continue to elevate and push the envelope of how they show love for this lowly, but lovely form of art—the sneaker. After all:

"Every sneaker has a soul and every sole has a story."

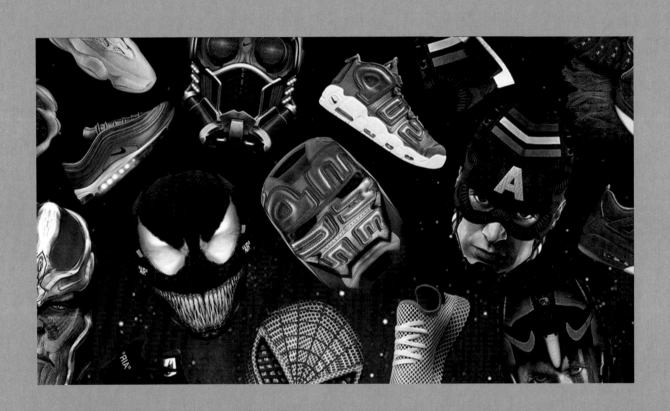

LOS ANGELES, CA

COLE

JEFF

JEFF COLE

Social media plays the role of kingmaker when it comes to sifting through the multitude of artists and voices trying to break through the noise.

Anointed with the appropriate hashtag, anyone can claim to be a model, rapper, designer, or artist. This saturation can be wonderfully democratic, but it can also—and frequently does—drown out real talent lacking the required modern marketing skills. When someone figures out the right recipe for hitting it with the masses, it's a good idea to sit up and pay attention to how they did it.

Jeff Cole has meticulously curated his own formula for breaking through the air-tight, algorithmic barrier of Instagram. Drawing inspiration from the tactics of attention-grabbing greats like M.C. Escher and Salvador Dalí, Cole found his own artistic style, creating a unique junction between beloved and recognized sneakers and new and notorious pop culture icons. His widely admired mashups take the most current materials in the zeitgeist and ignites a spark of curiosity in the viewer. The work has proven to make one stop scrolling and feel transported as if standing in front of a piece in a museum.

WWW.IKONICK.COM

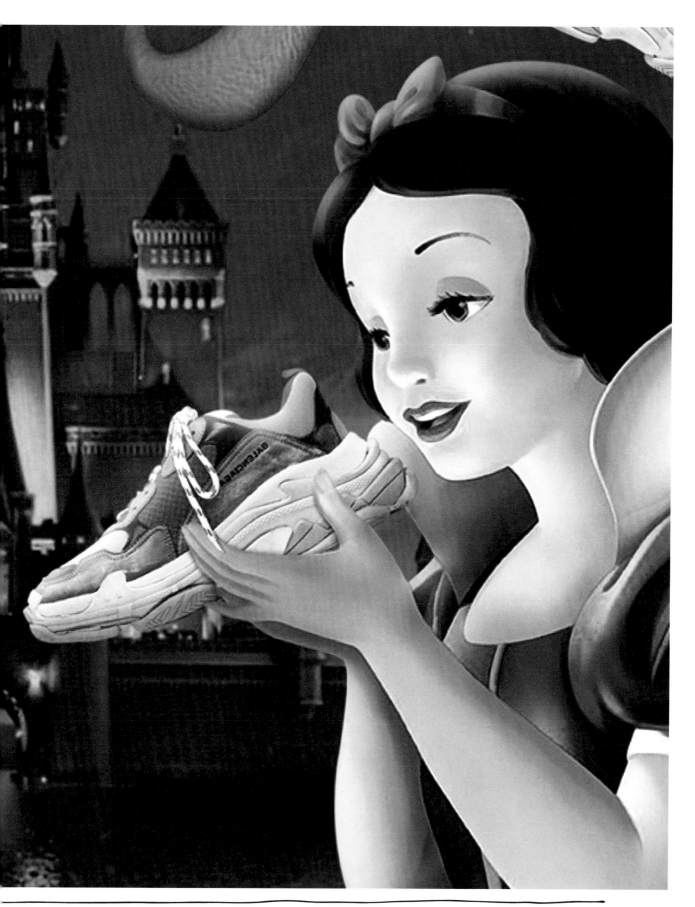

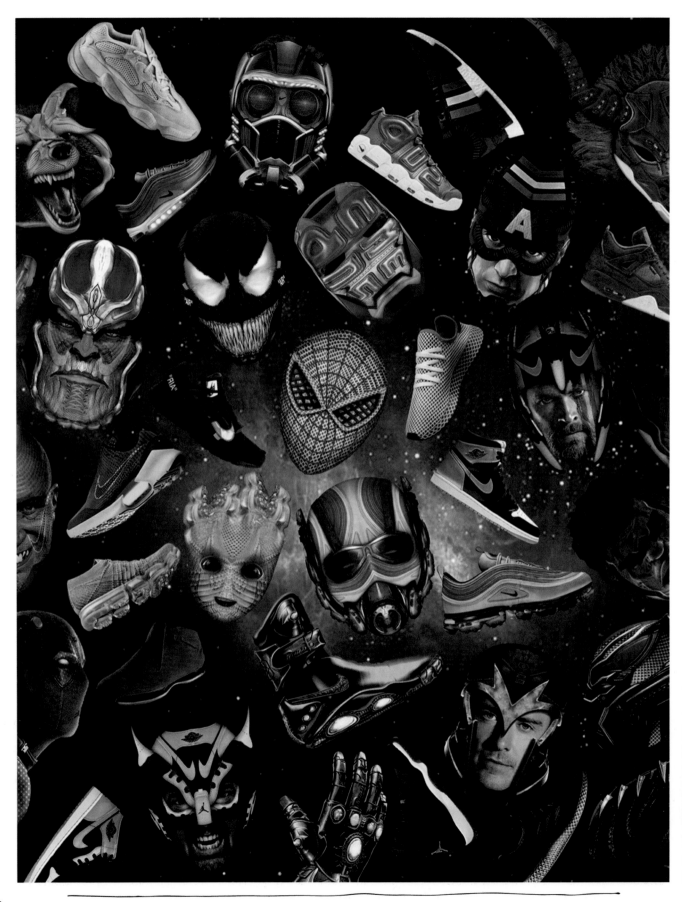

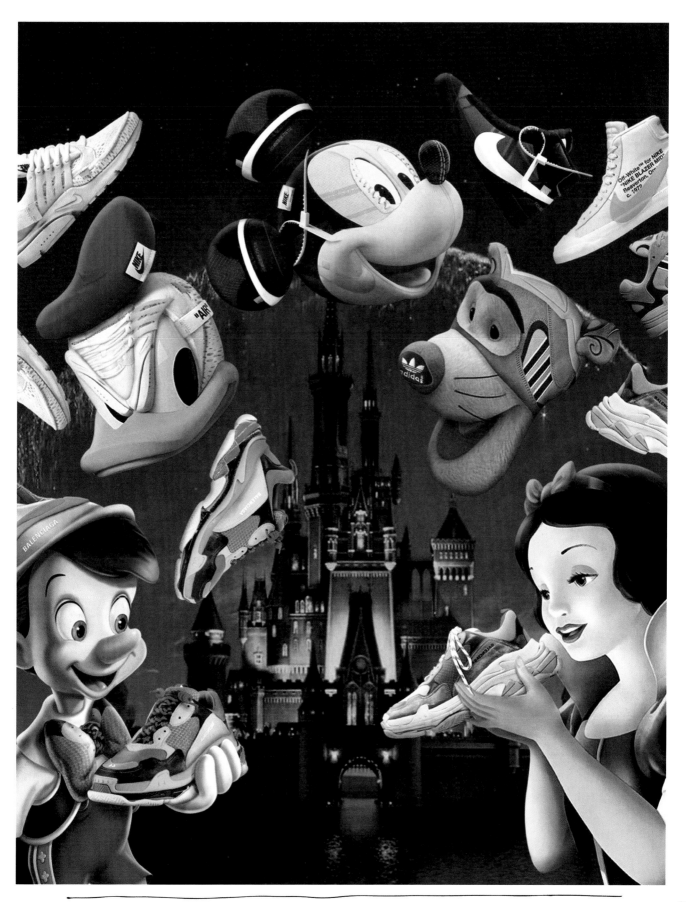

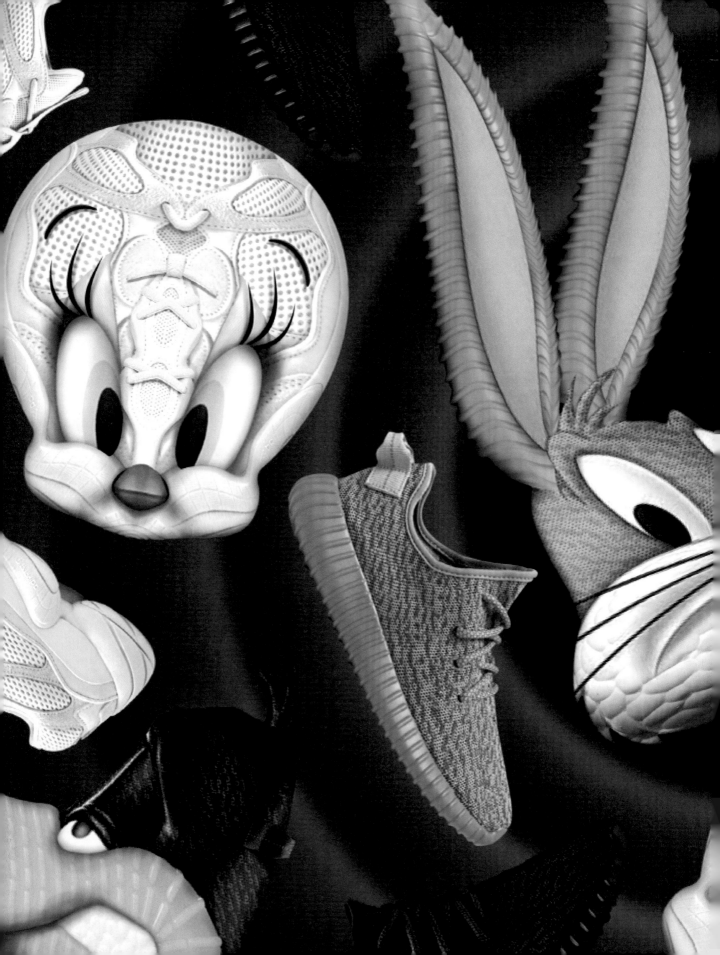

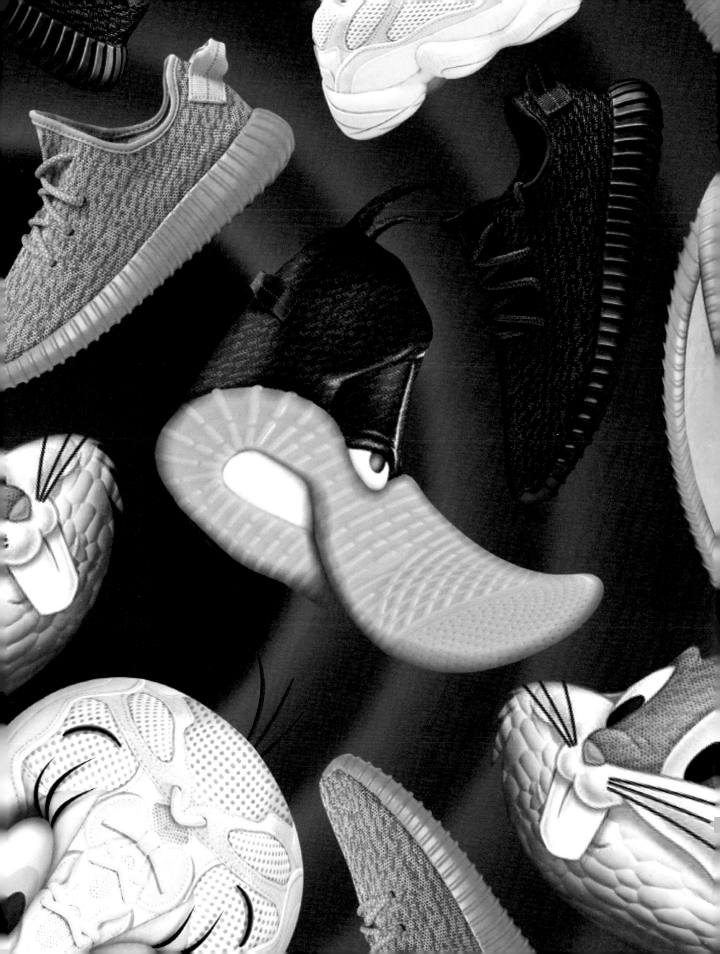

ALEC DEMARCO

ALEC
DE MA R CO

FALLBROOK, CA

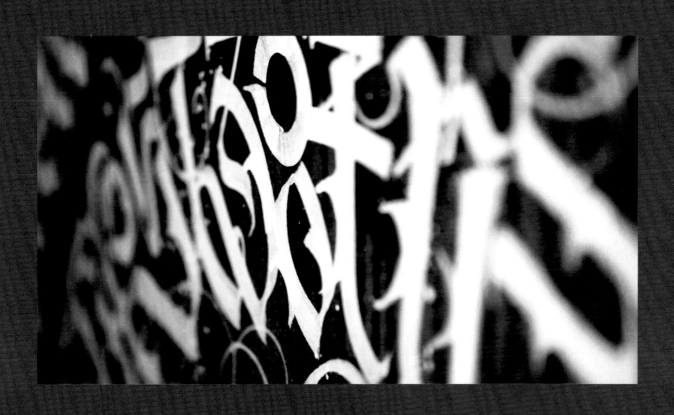

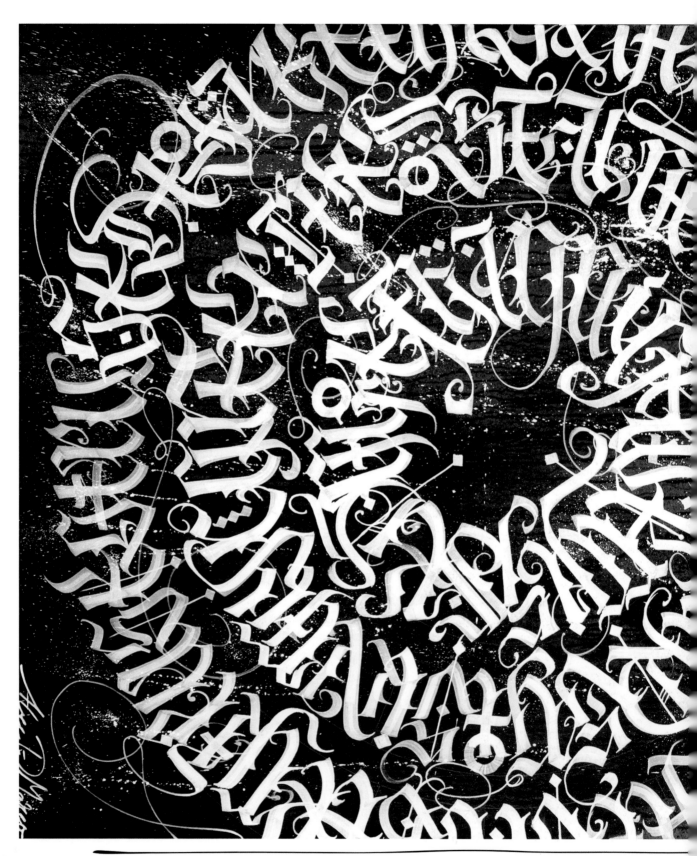

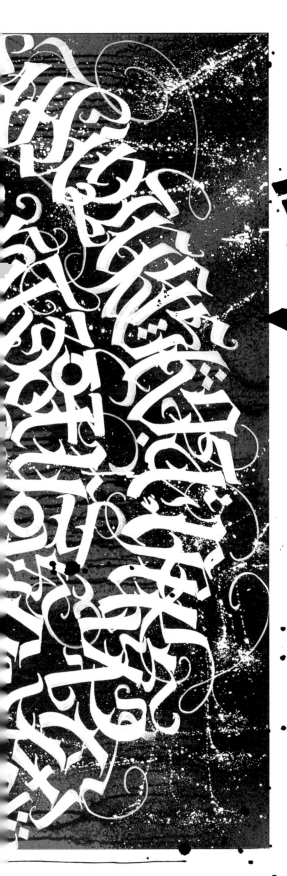

Alec DeMarco is a multi-talented artist living in Southern California. He is working to carve out a unique visual language emphasizing the synthesis of the visual and the auditory using the gestural aesthetics of Asian, Western, and Middle Eastern writing styles.

Crossing cultural boundaries in a conceptual approach to fuse multipe cultures and place the past in service of the present. DeMarcoís art practices involve experimenting with a wide range of materials and media often combining traditional crafts, repetitions, and abstract innovative techniques.

Alec (born 1989) studied fine art and illustration at Laguna College of Art and Design. After college he was accepted into a 3 year traditional apprenteship with a Japanese Irezumi tattoo master. During the formal apprenteship he was taught about Eastern philosophy, religion, mythology, calligraphy, and much more.

WWW.ALECDEMARCO.COM

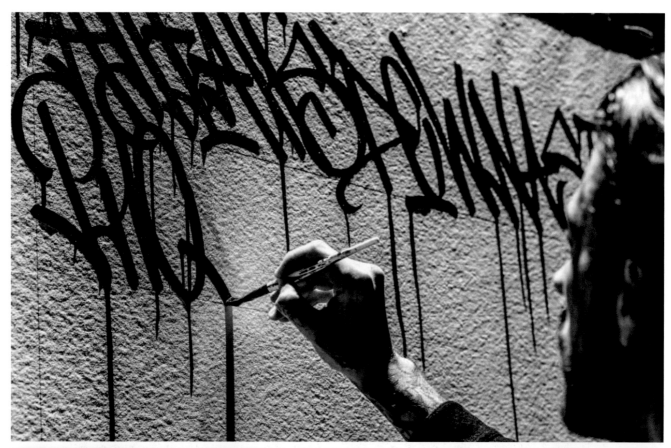

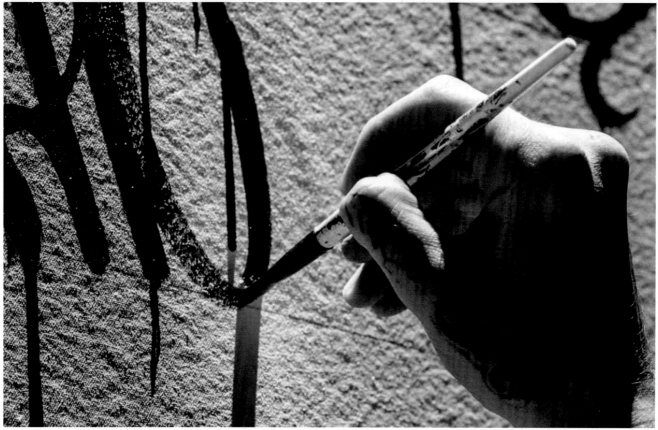

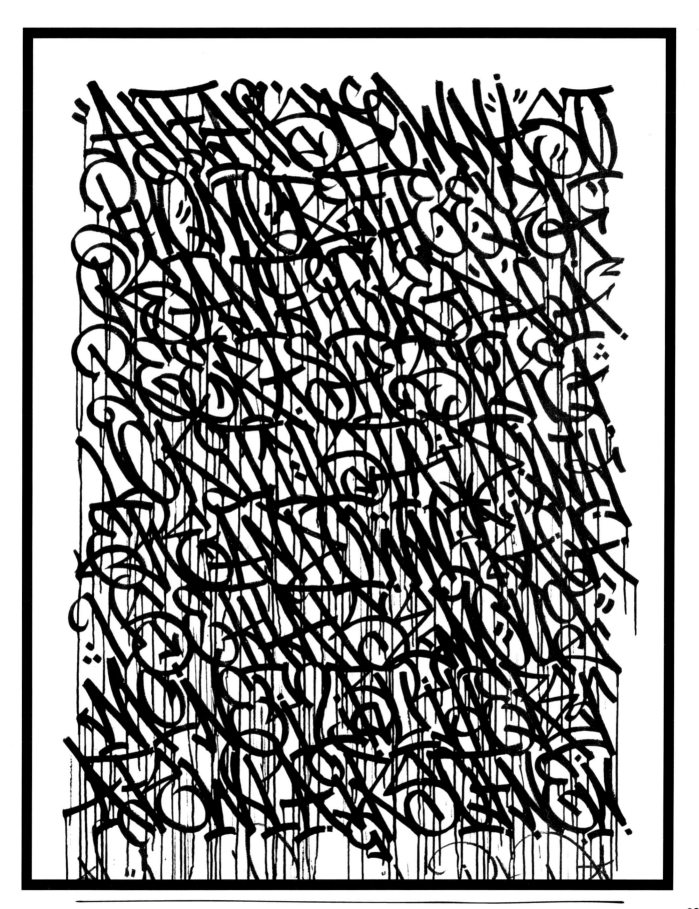

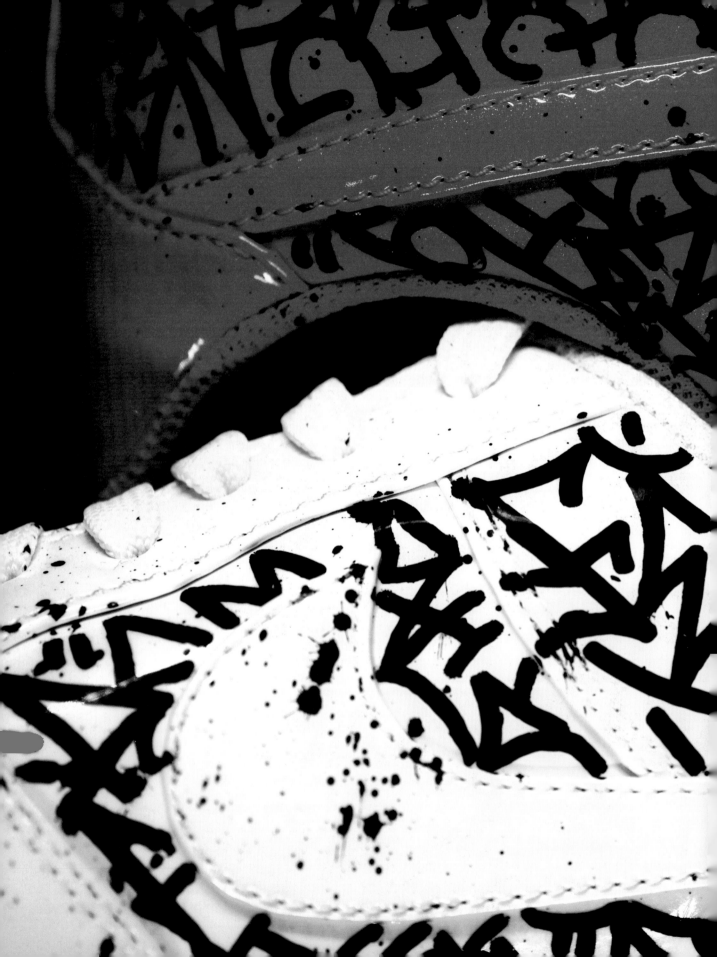

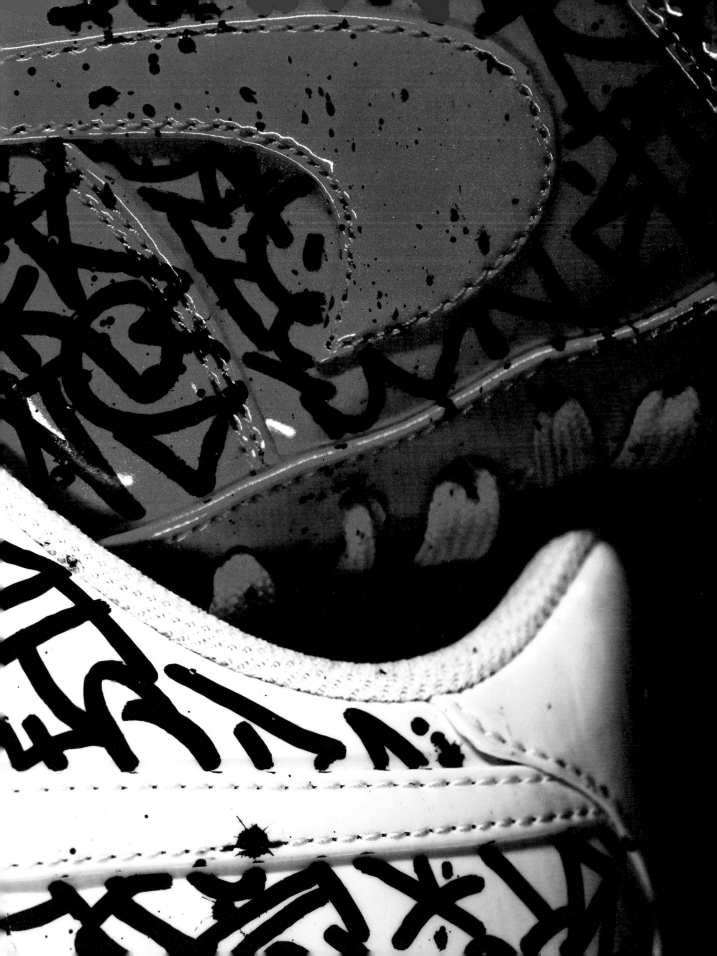

FREEHANDPROFIT

FREE HAND PROFI T

LOS ANGELES, CA

Hip-hop music popularized the art of the remix, which involves taking the bones of a song and adding or removing elements until it resembles something else entirely. Inspired by this rip-it-apart-and-rebuild-it mentality, Freehand Profit has made a name for himself by both horrifying and delighting sneaker fans with his mask creations.

It's a process that can be traumatic to witness. Taking what are particularly coveted shoes and literally, methodically ripping them to pieces, he turns that violence into something sublime. In doing so, he is able to break down these idolized items into their fundamental parts, giving the viewer an entirely new appreciation for both what the object once was and what it can become under his skillful hand.

There is a particular darkness to much of Freehand's work—his gas masks riff on the ongoing degradation of our environment as well as the risks we all face in a world that frequently seems on the brink. It is an undercurrent that seems at odds with the escapist nature of sneaker culture, and it's that tension that makes his work so visceral.

WWW.FREEHANDPROFIT.COM

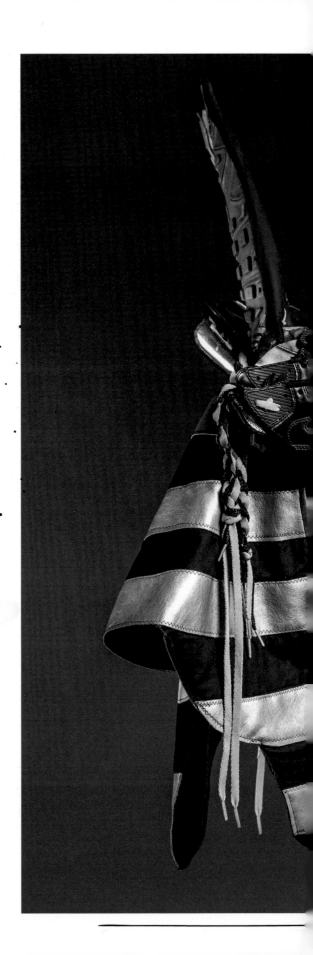

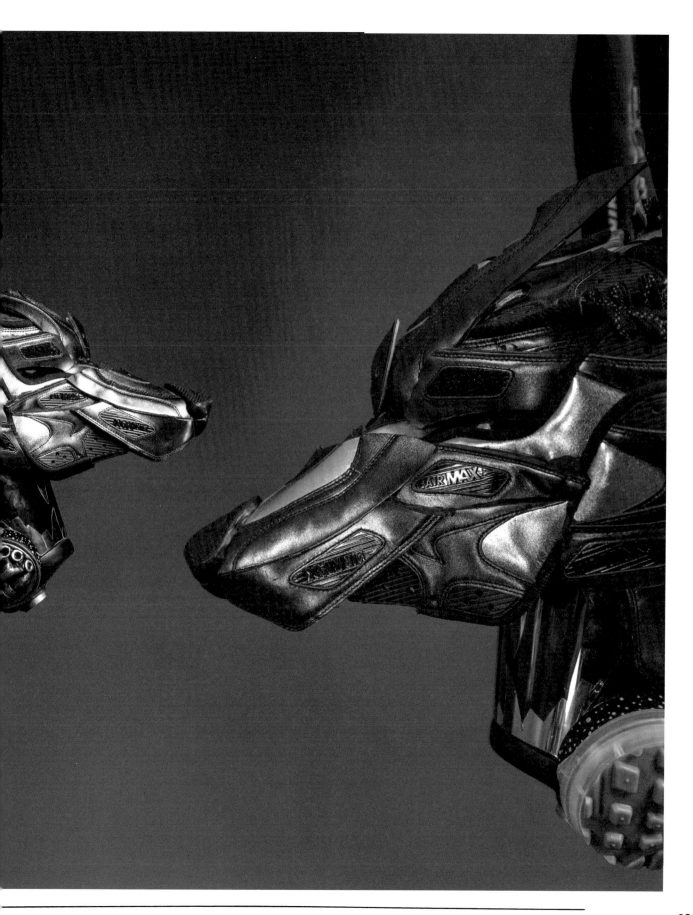

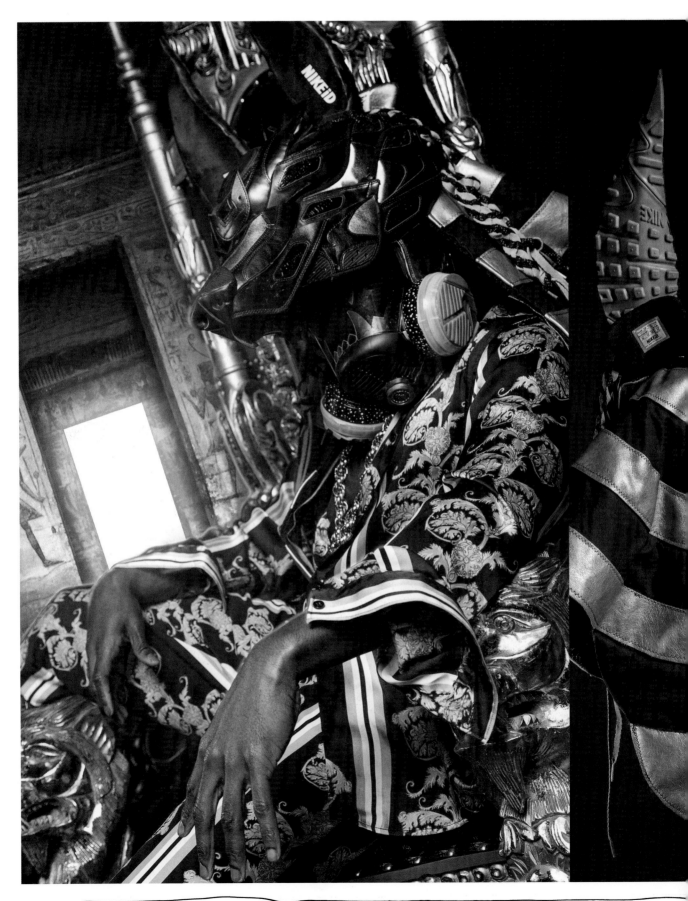

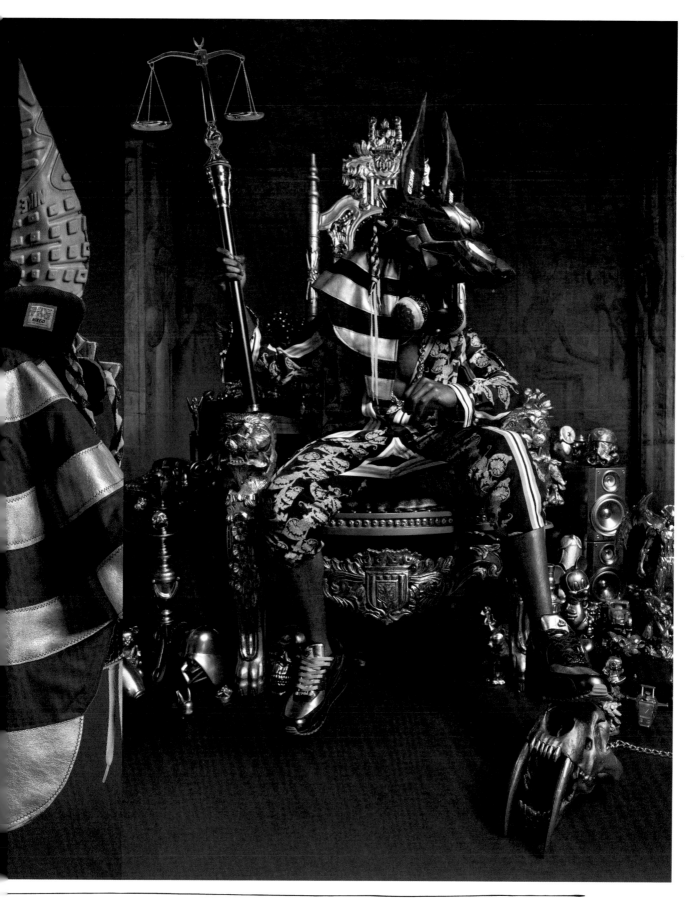

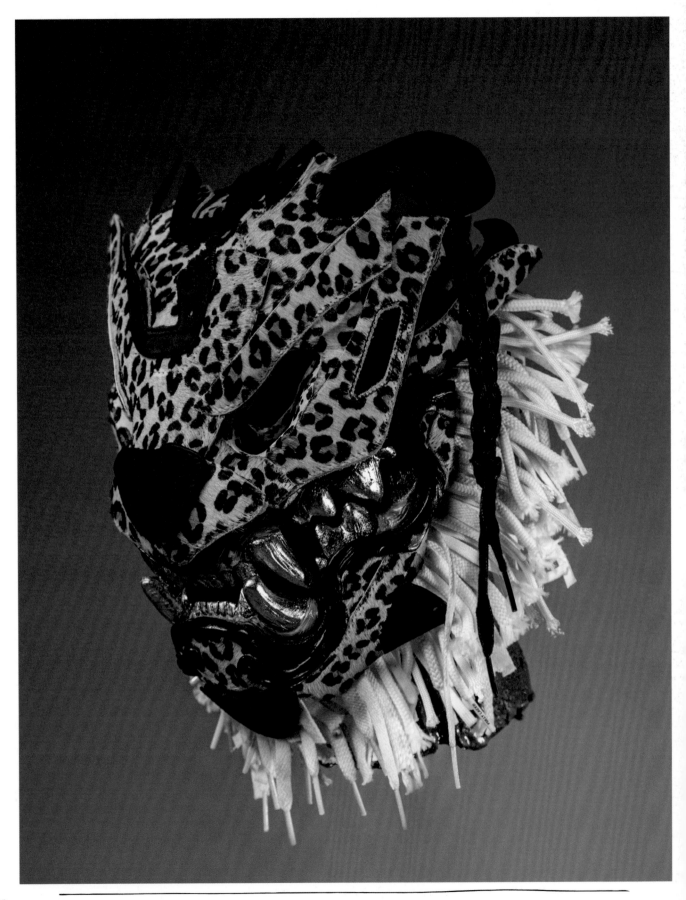

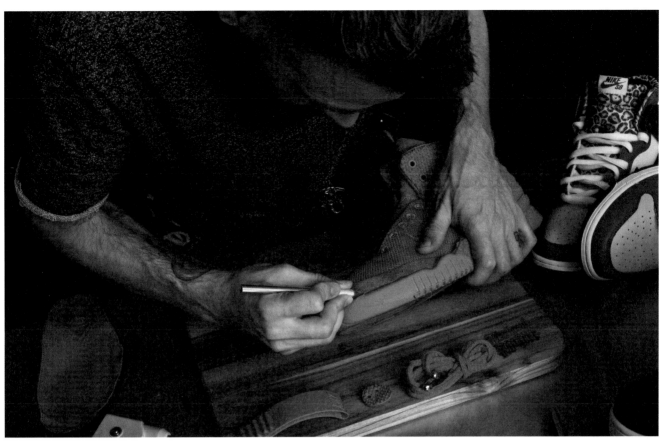

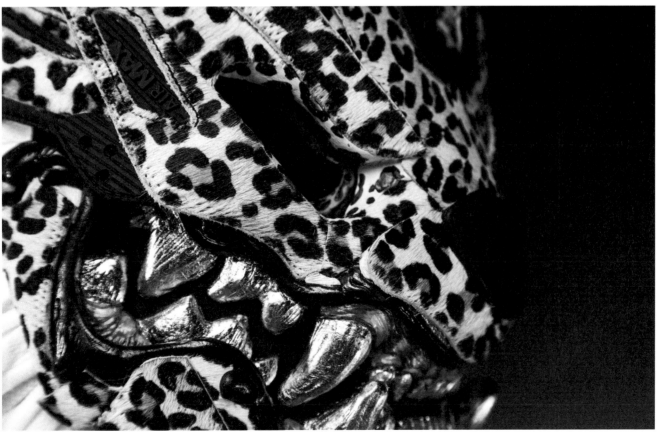

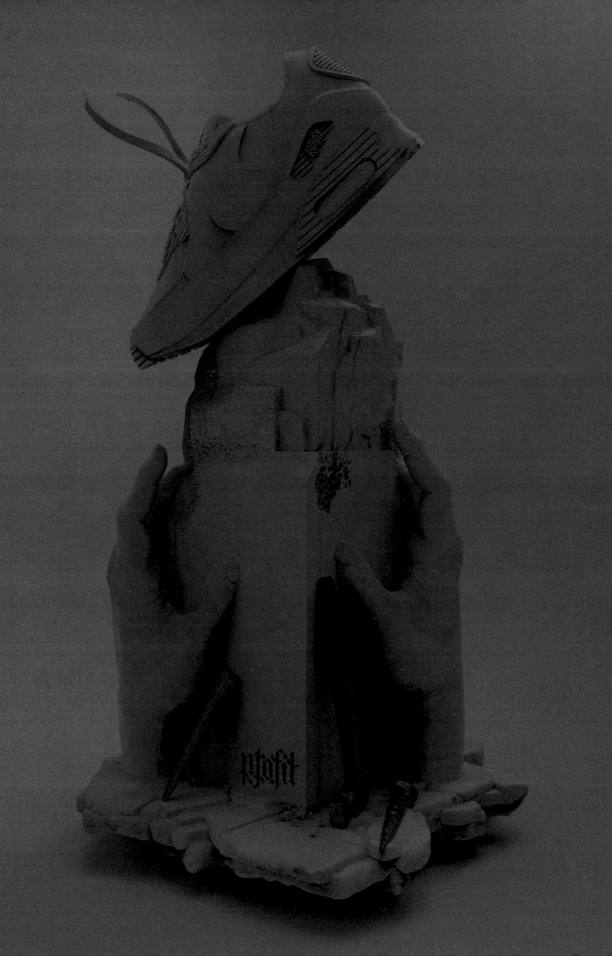

"THE OVERALL GOAL IS HAPPINESS BECAUSE WHEN I'M NOT MAKING ART I AM UNHAPPY. SO I DAMN WELL BETTER MAKE A LIVING AT IT."

—FREEHAND PROFIT

HONORROLLER

HO N OR

RO LLER

BROOKLYN, NY

The smallest things can leave long-lasting impressions. Just ask woodworking artist Christopher Chan, also known as Honorroller.

A small wooden monkey owned by his grandfather set the course for an artistic path that has taken Chan from Toronto to Brooklyn, where he crafts his one-of-a-kind designs. Starting with graphic design while in art school, he transitioned to illustration and then finally to sculpture.

Influenced by hip-hop and inspired by vinyl toy designers, Honorroller creates detailed, fully articulated wooden puppets of his favorite characters. Choosing wood as a medium, Chan was drawn to its living, ever-changing nature.

As he honed his woodworking skills he graduated to constructing ever larger pieces, landing on his now iconic sneaker planters, which have adorned the shelves of galleries, art collections, retailers, and even talk shows.

And it all started with that little wooden monkey.

WWW.HONORROLLER.COM

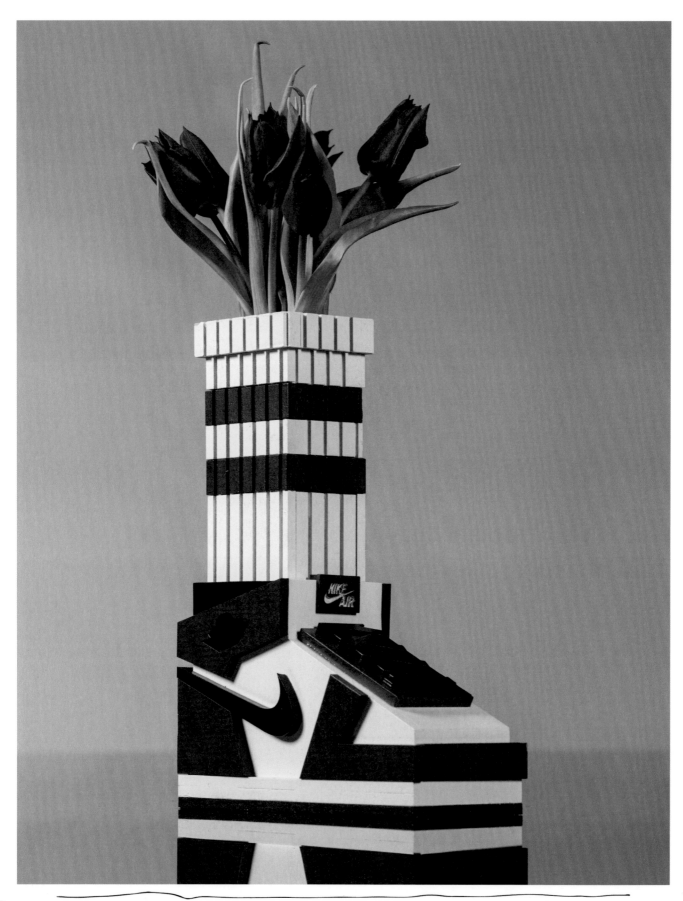

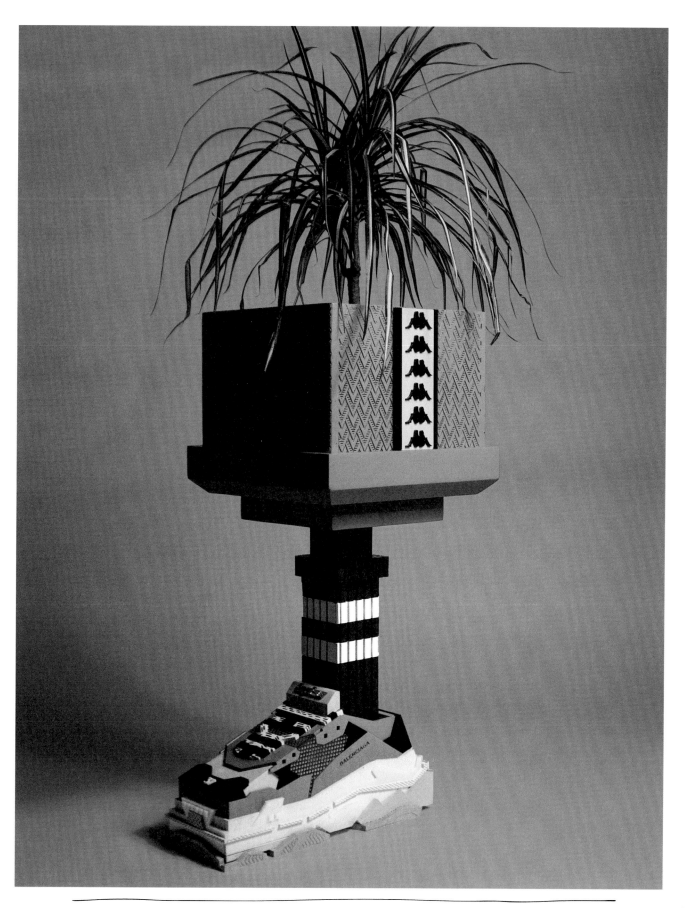

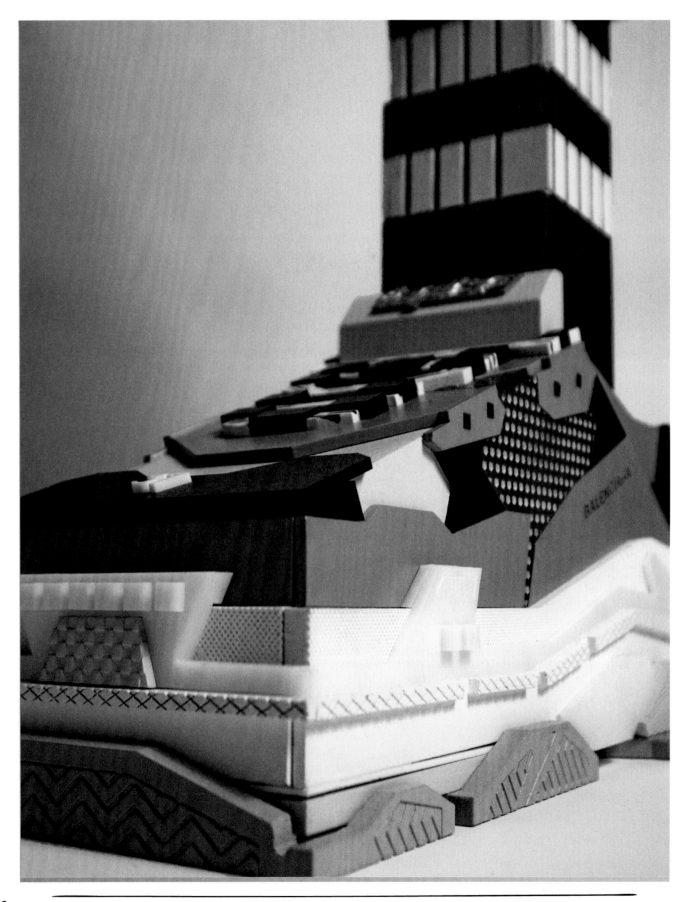

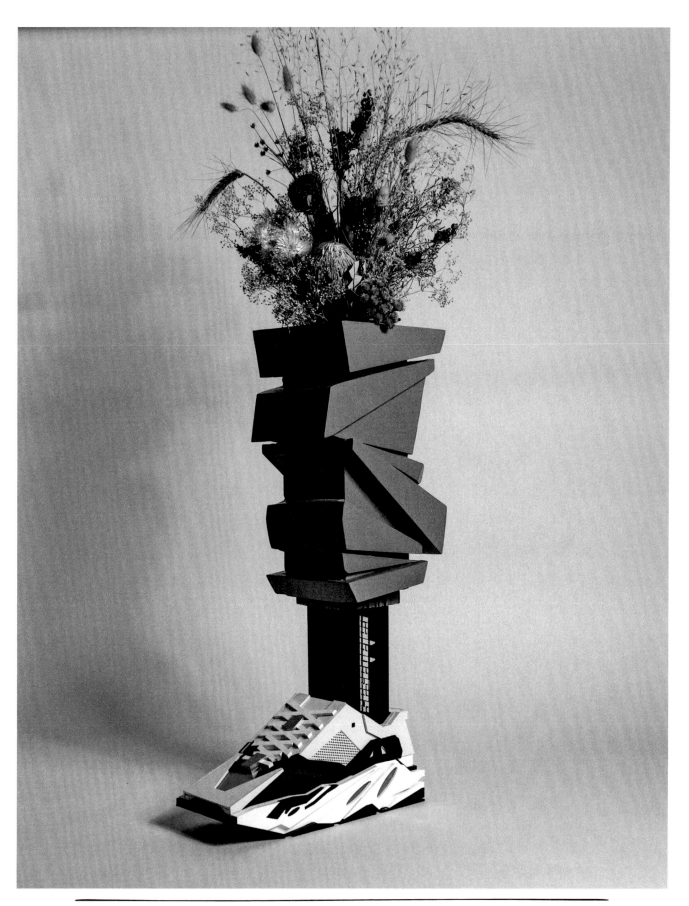

CESAR IDROBO

CES AR

ID ROB O

PORTLAND, OR

It may not always be clear to most sneaker aficionados, but footwear designers share a language with those who create any number of familiar yet seemingly unrelated objects.

Just as a sports car designer is concerned with melding fuel efficiency through aerodynamics with safety and aesthetic appeal there are both practical and emotional considerations in designing a sneaker.

Colombian-born designer and illustrator Cesar Idrobo focuses his gaze on those unexpected similarities between creative fields in the work he has contributed to this volume. He is inspired by finding those congruencies and building upon them, and has harnessed the power of technology to help do so.

Algorithmic-aided design uses 3D computer programs that control the geometries of structural forms by incorporating environmental analysis. The results are models that reach a level of precision, complexity, and capability that supersedes what a human hand could ever do. The robots are officially winning, and after having taken his talents to companies like Nike, BMW, and Adidas, Idrobo is also currently winning as one of Kanye's in-house designers at West Brands.

WWW.BEHANCE.NET/CESARIDROBO

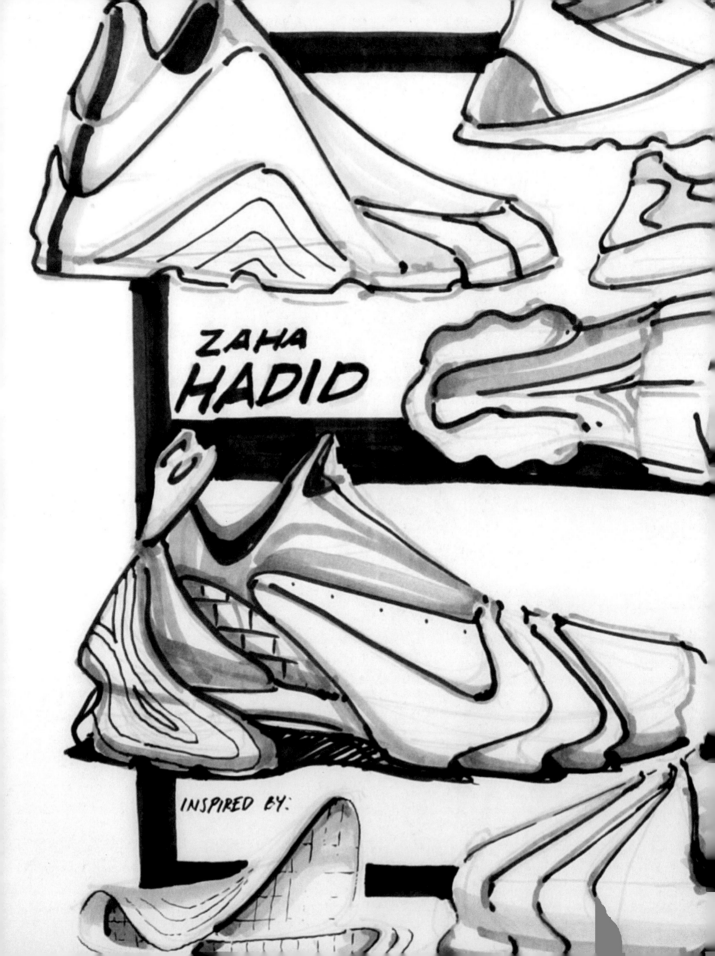

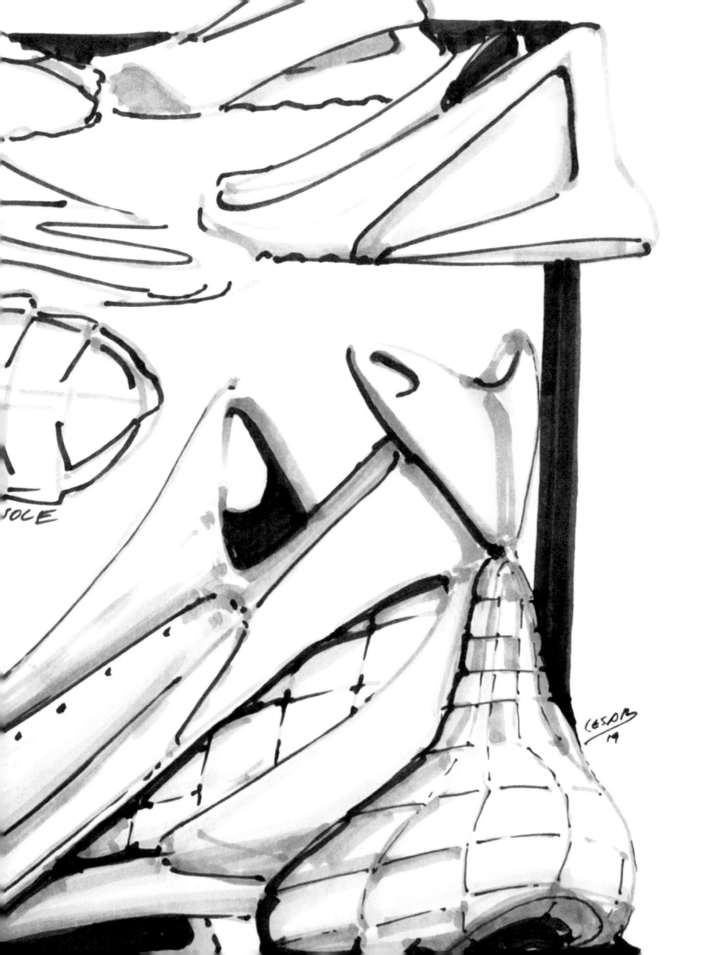

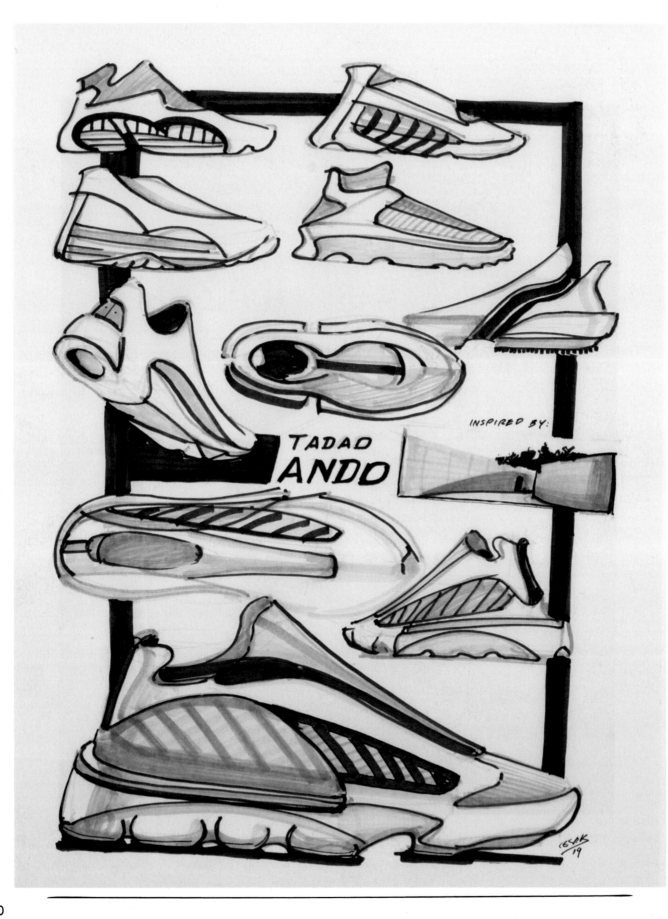

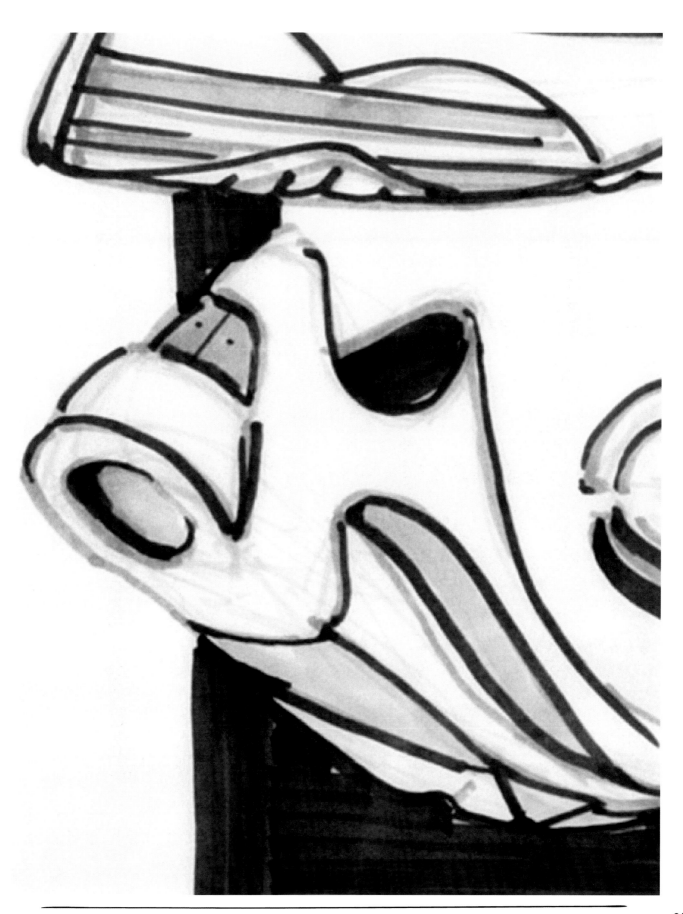

KENROCK

KE N
R O CK

NEW YORK, NY

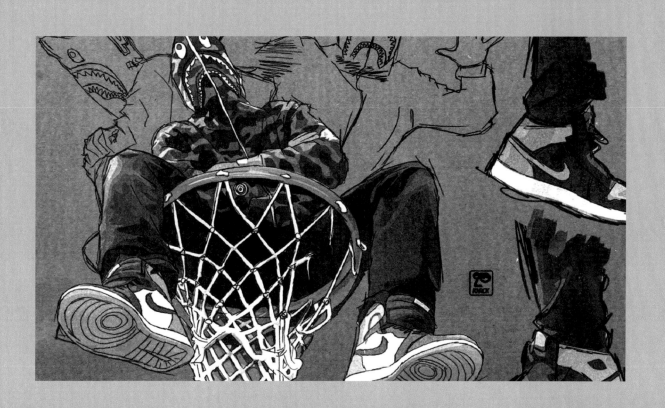

Ken0ck's work pulses with an energy that anyone who has been to his Queens borough will find familiar. There is a uniquely New York vibe to his work, and the artist has developed a trademark style that seems to mimic the many facets of his environment.

Playing off the aspiration behind the hype, Ken0ck taps into the hippest, most "now" trends that his keen eye takes note of on the streets.

The swag his characters embody is unmistakable, but contrary to the bold, in-your-face colors and designs that mark most popular brands today, the artist's use of watercolor and texture in his work seems to give a warmth to the often sterile brands he references.

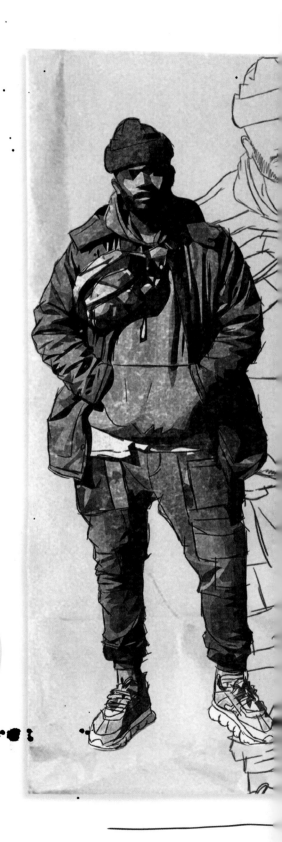

www.ken0ck.com

054

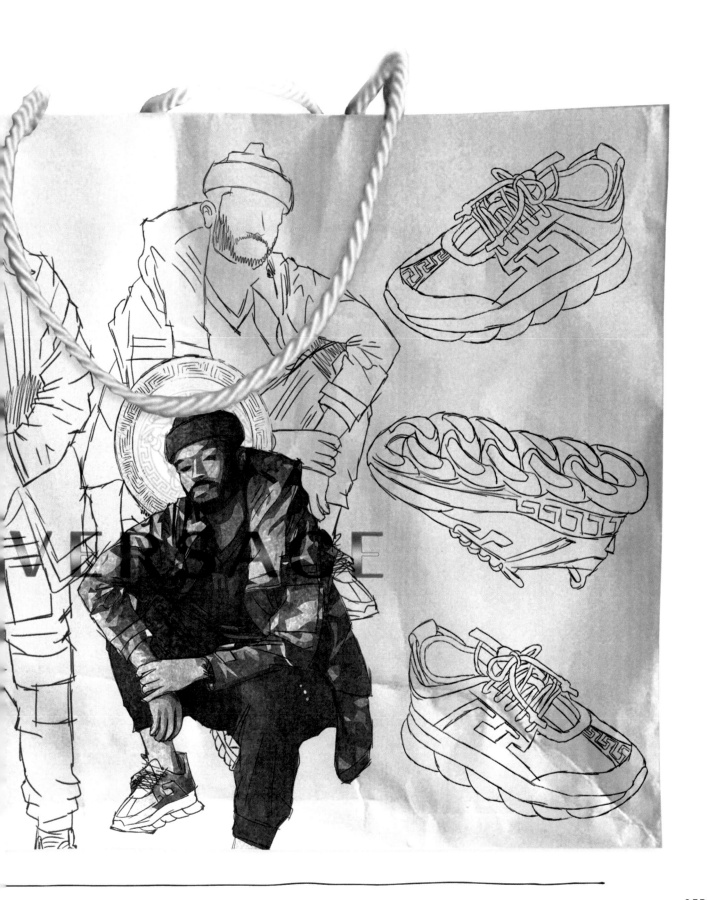

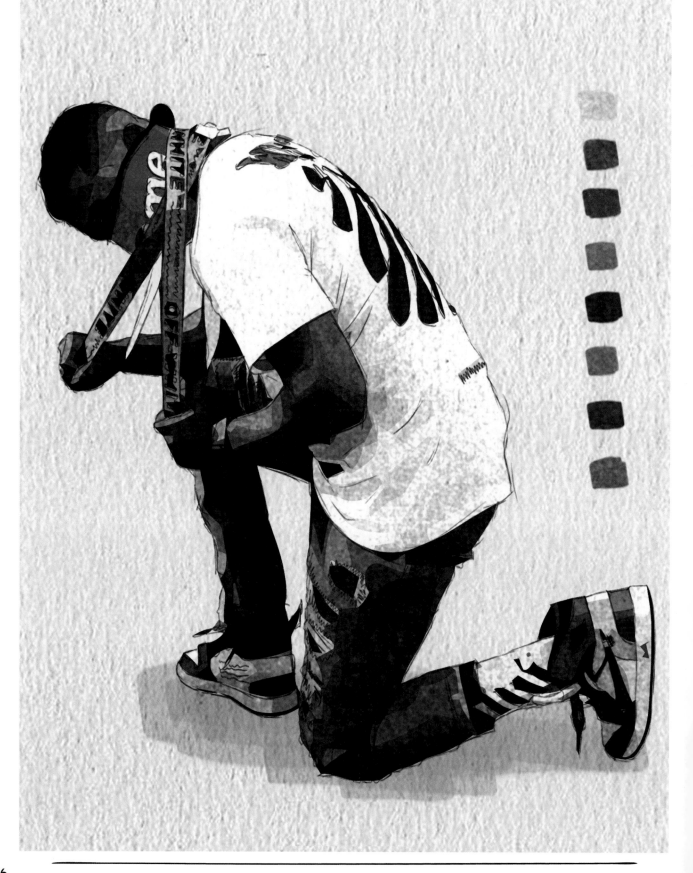

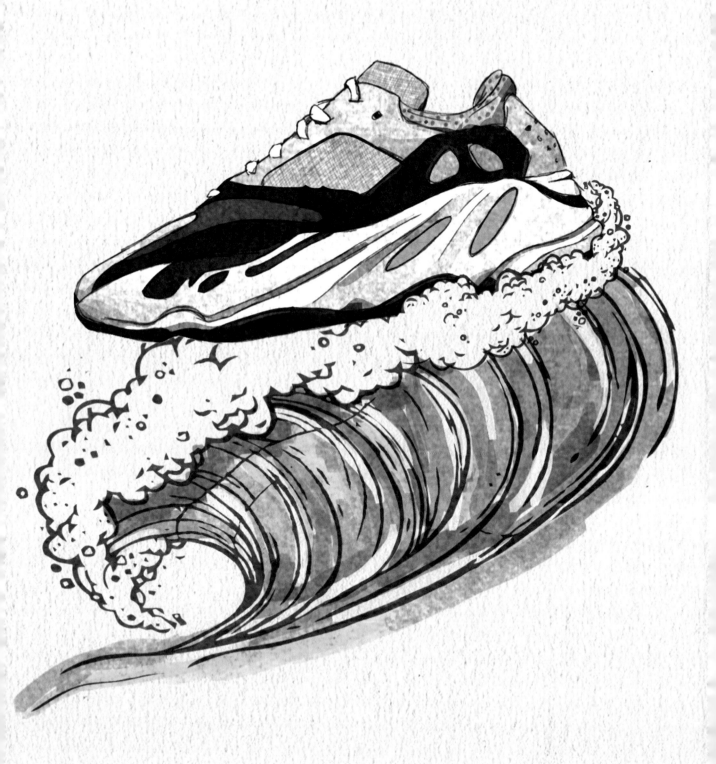

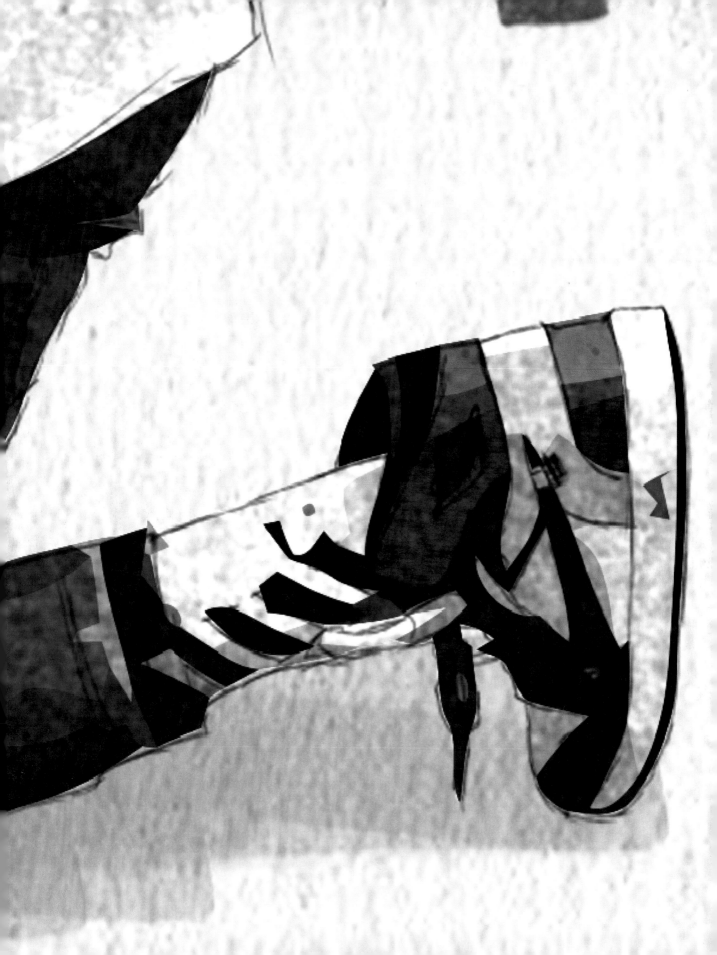

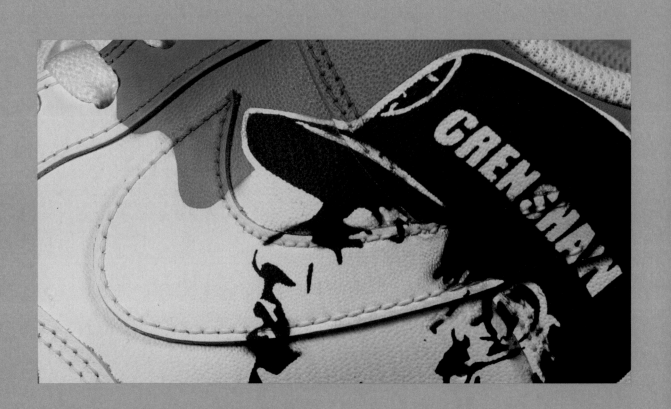

KICKSTRADOMIS

KICKSTRADOMIS

LOS ANGELES, CA

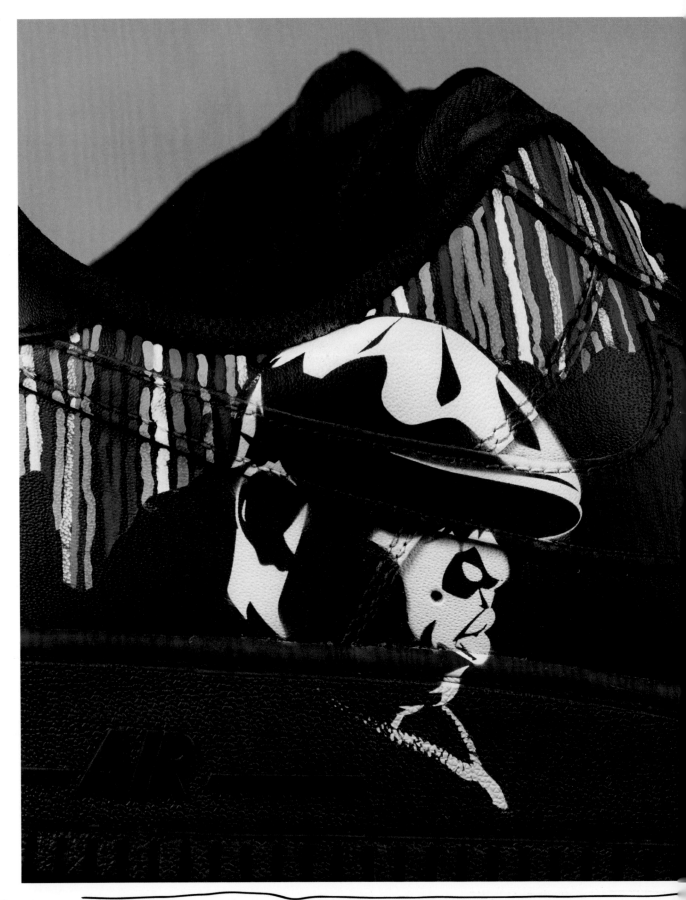

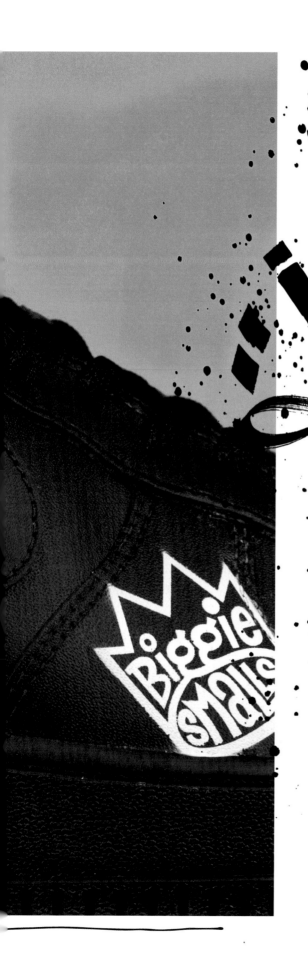

Throughout this book are artists who have collaborated with some of the biggest brands in both sneaker culture and mainstream culture, but only one resides in the contacts of the athletes that help define each.

Salvador Amezcua, aka Kickstradomis, went from working at Finish Line to making a living creating custom kicks for some of the biggest names in the NBA. He was at the forefront of what has become a massive customizing trend within the league, and the work he and other customizers do is influencing brands in a significant way.

"You can tell that the big dogs are watching us. They bring out colorways that are very similar—almost exactly the same—to pairs that I've done or that other artists have done. You know they're watching."

For his contribution to The Art of Sneakers, Amezcua chose to pay tribute to a trio of iconic hip-hop legends, incorporating their portraits as well as his own trademark "drip" look.

Kickstradomis

WWW.KICKSTRADOMIS.COM

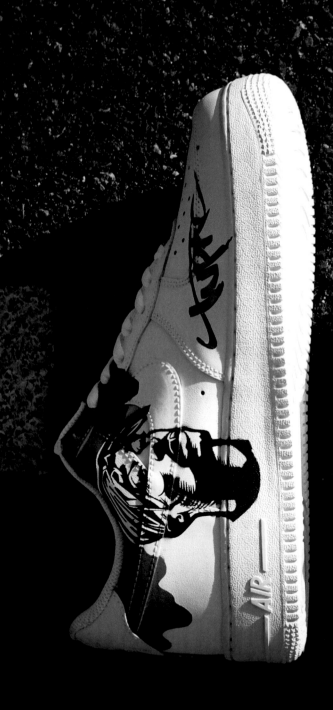

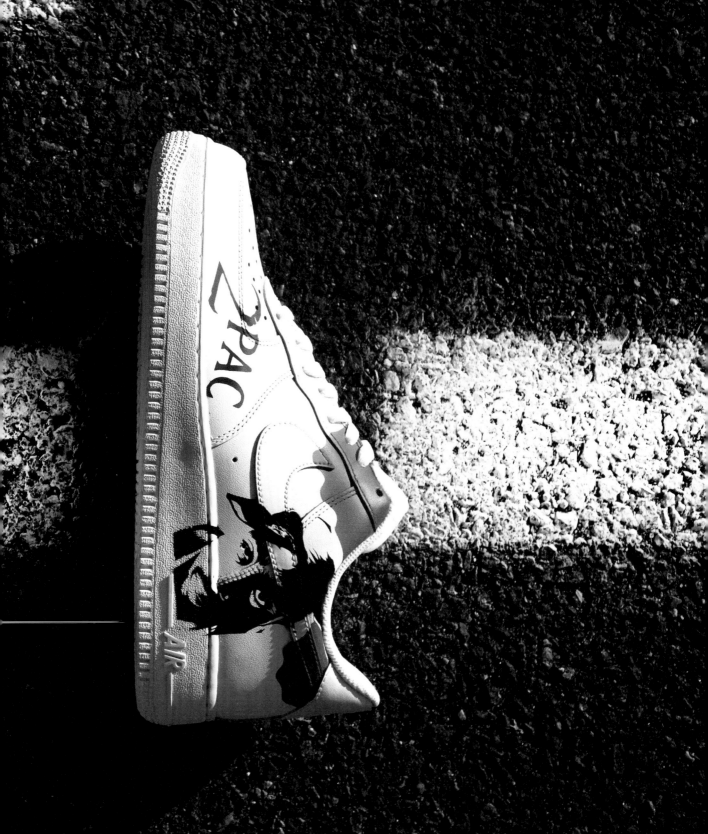

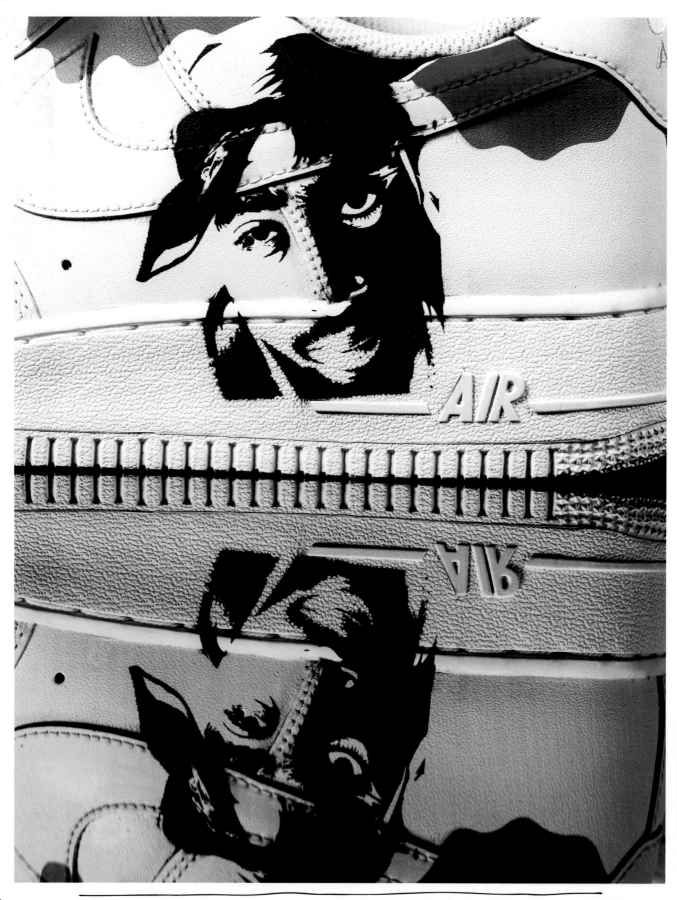

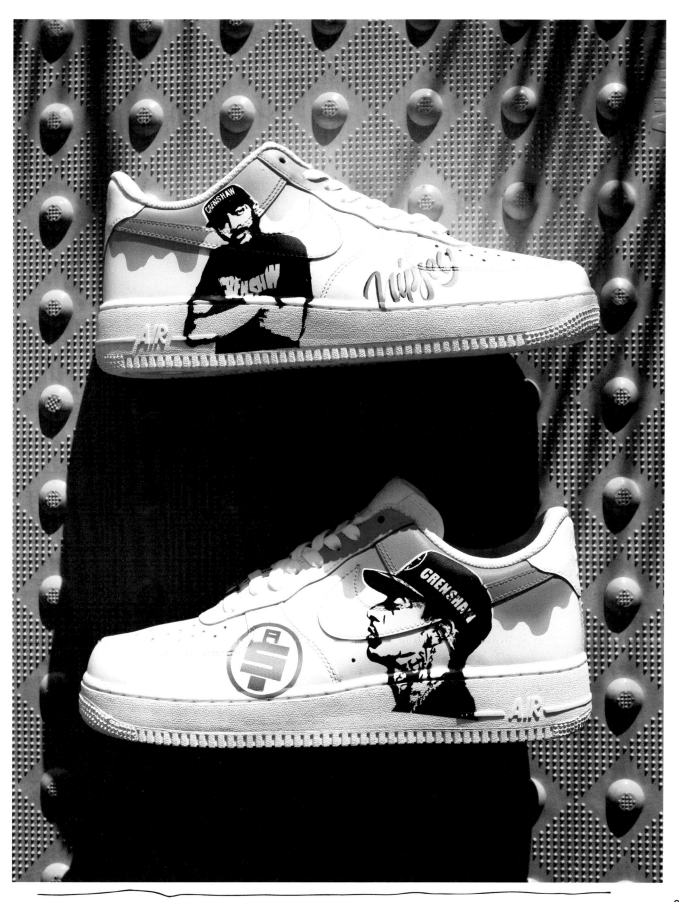

"SNEAKERS INSPIRE ME T
ALL SNEAKERS ARE DIFFI
MODELS, FORMS, TEXTU
CREATIVE AND DIFFEREN

CREATE ART BECAUSE
ENT. THERE'S DIFFERENT
ES. IT JUST KEEPS IT
"–KICKSTRADOMIS

LAR O

LAG O STA

LARO LAGOSTA

PORTO, PORTUGAL

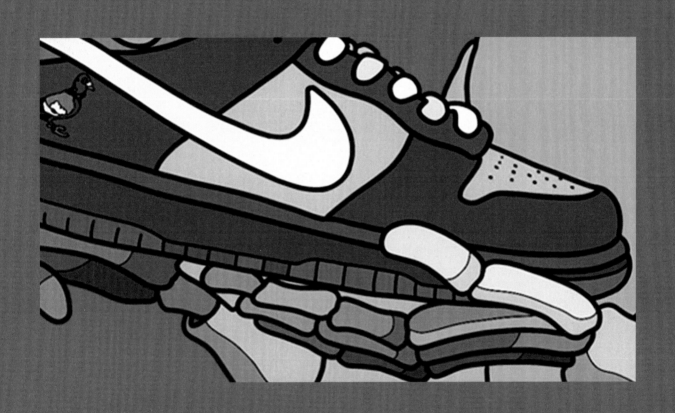

Long gone are the days when sneaker culture was considered "underground" and strictly for the edgy insiders who shaped the world of cool.

Today it's become a living, breathing manifestation of the consumerism that drives much of society. It is in the eye of this hype-storm that Portuguese illustrator and graphic designer Laro Lagosta enables us to view sneaker culture from a less serious, even comedic, perspective.

A comedian's best work typically blossoms when they are able to draw from their own personal experience, and Lagosta imbues his work with a keen wit gleaned from his own sneaker obsession. A guilty participant in the world of hype himself, Lagosta hilariously satirizes the life of a sneakerhead in ways that ring true to anyone who lives it.

The use of skeletons in his recent works are Lagosta's method of breaking through identifiable or perceived stereotypes of a person. By leaving his subjects un-gendered and un-colored, he allows the viewer to more easily relate to the message he is conveying, which can frequently be summed up by the question, "Why so serious?"

LARO LAGOSTA

@LAROLAGOSTA

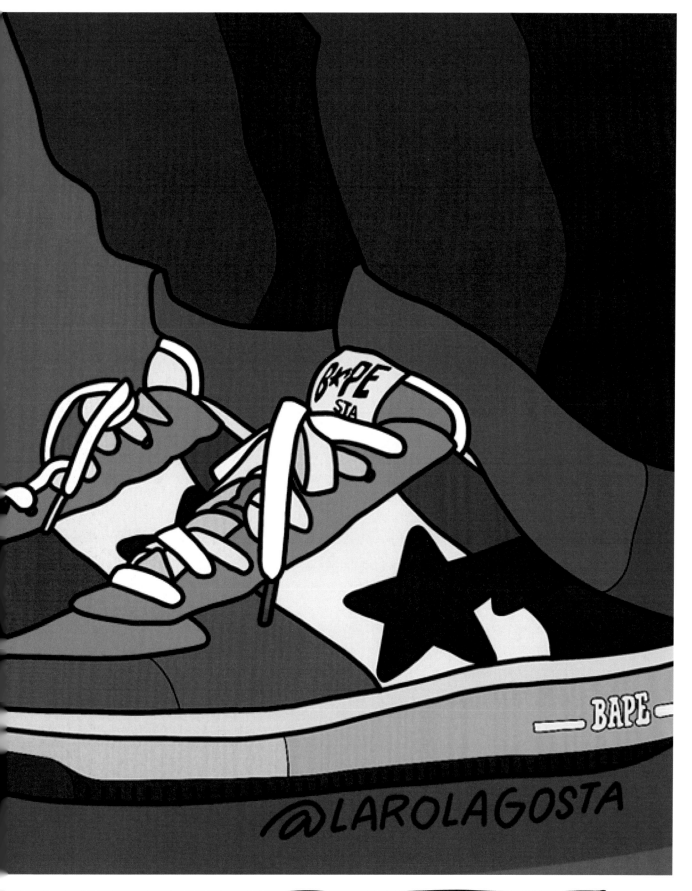

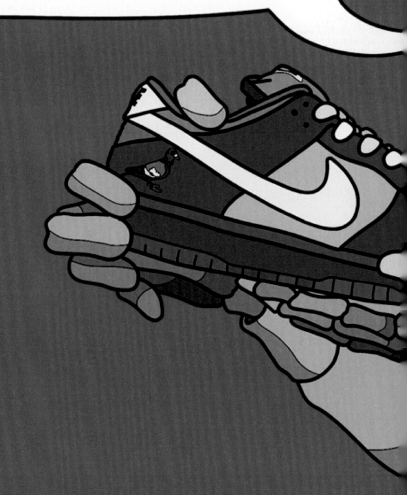

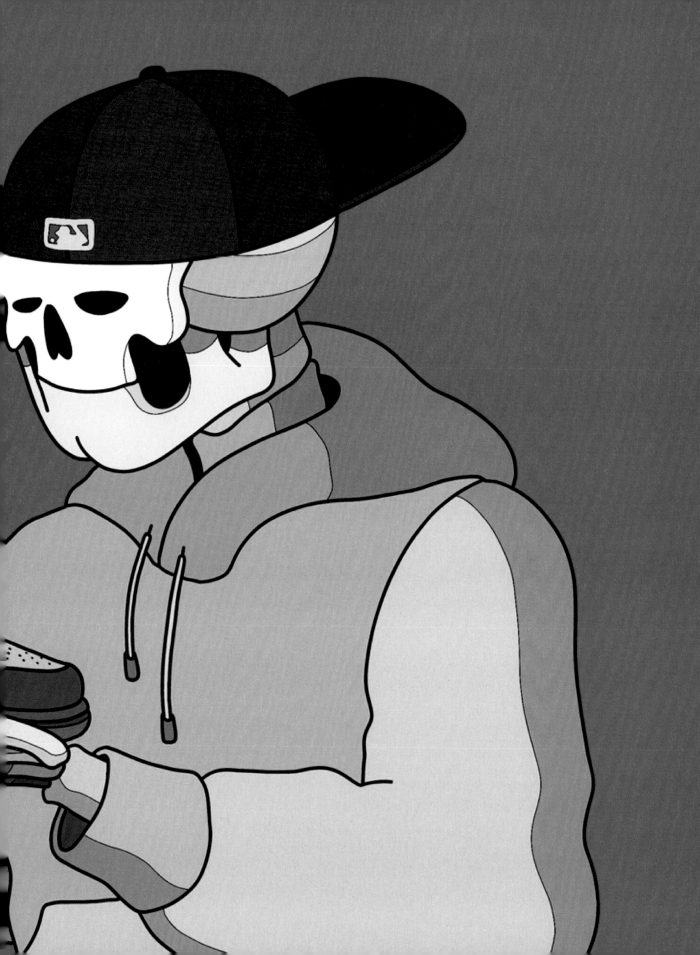

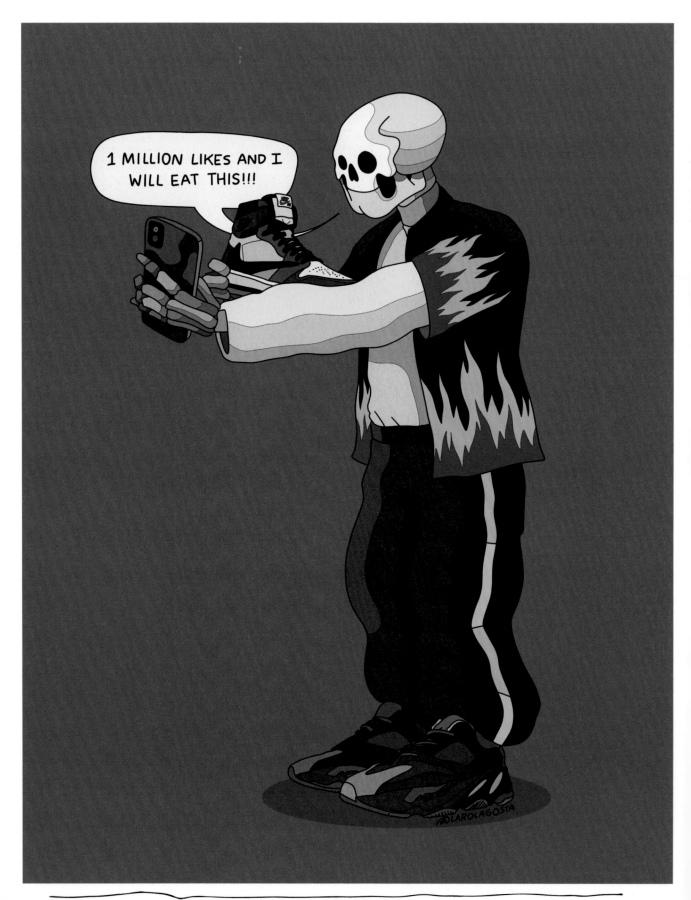

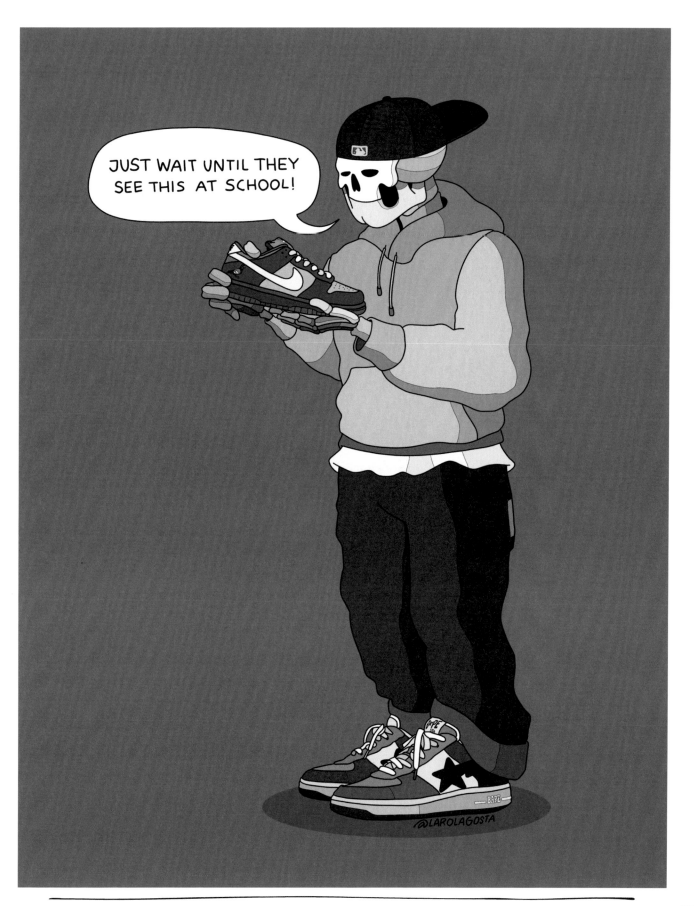

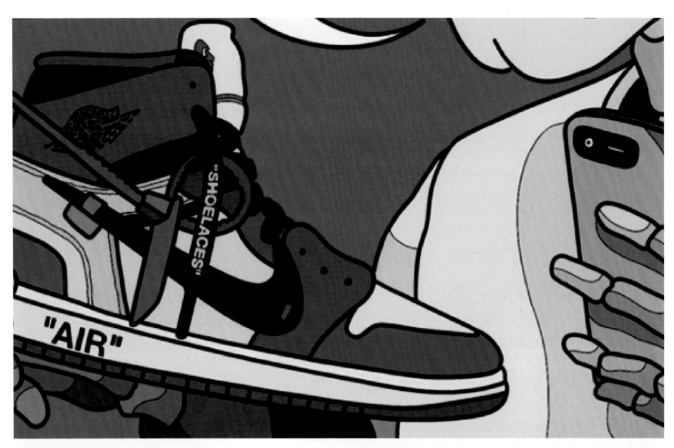

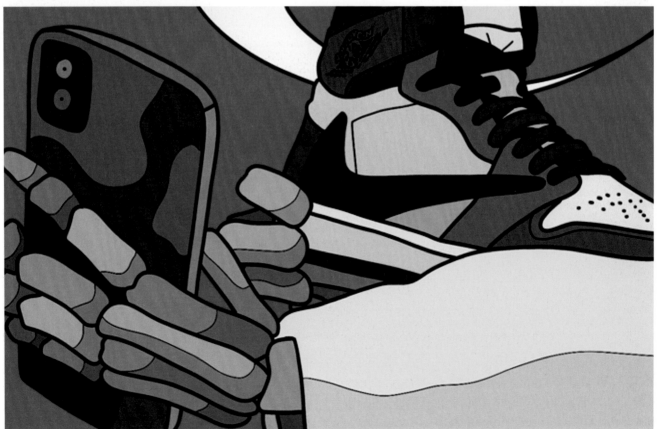

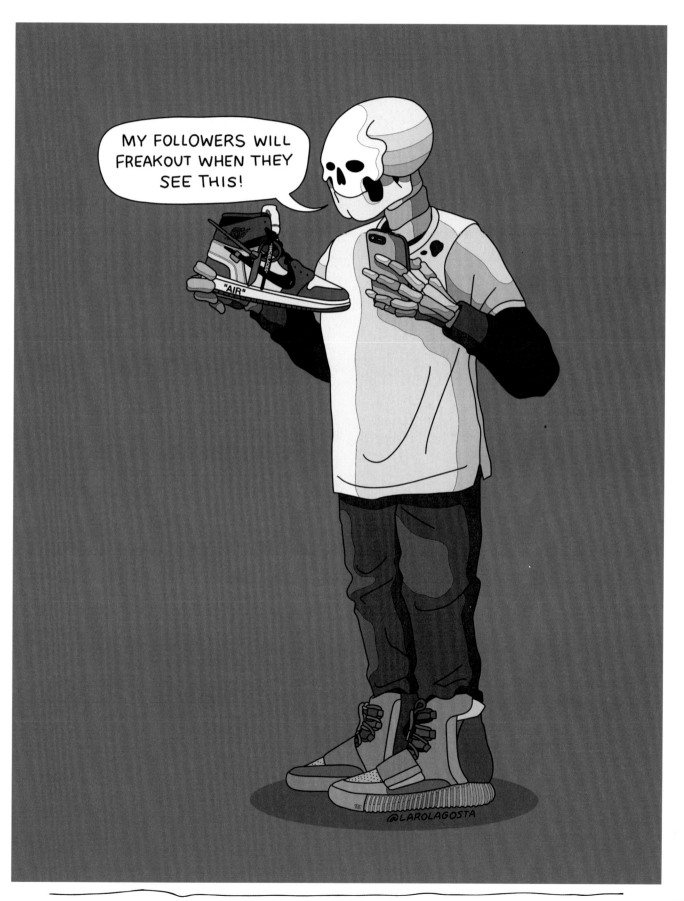

FLYY

M

C

LYY

MCFLYY

JERSEY CITY, NJ

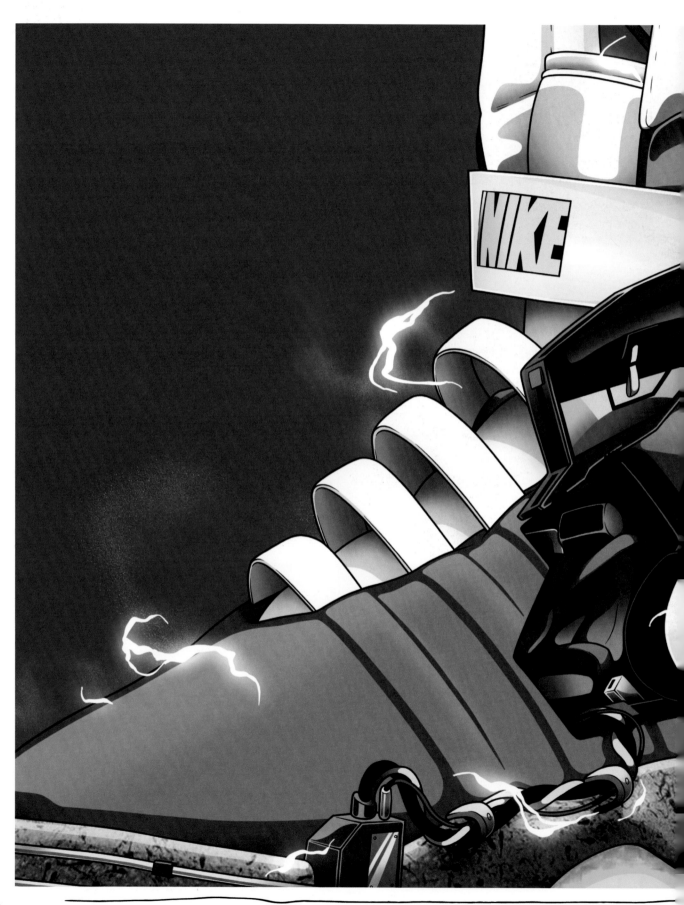

It's immediately clear from illustrator and graphic designer McFlyy's work that he is heavily influenced by the wildly popular illustration style known as anime. He counts classics of the genre Akira and Dragon Ball Z as inspirations as he rides this trend and continually finds ways to make it his own.

Everything in anime is exaggerated—hyper-violent, hyper-sexualized, hyper-imaginative. McFlyy takes these motifs and applies them to sneakers in a seamless manner. He seems to have an insight into what a given sneaker's real potential could be, giving them a singular character and attitude that broadens their already magnetic appeal.

. The artist has used these skills to great effect, not just in his wildly popular illustrations, but also in customizing apparel for celebrities and collaborating with industry giants on new looks.

McFlyy

WWW.MCFLYYSTUDIOS.COM

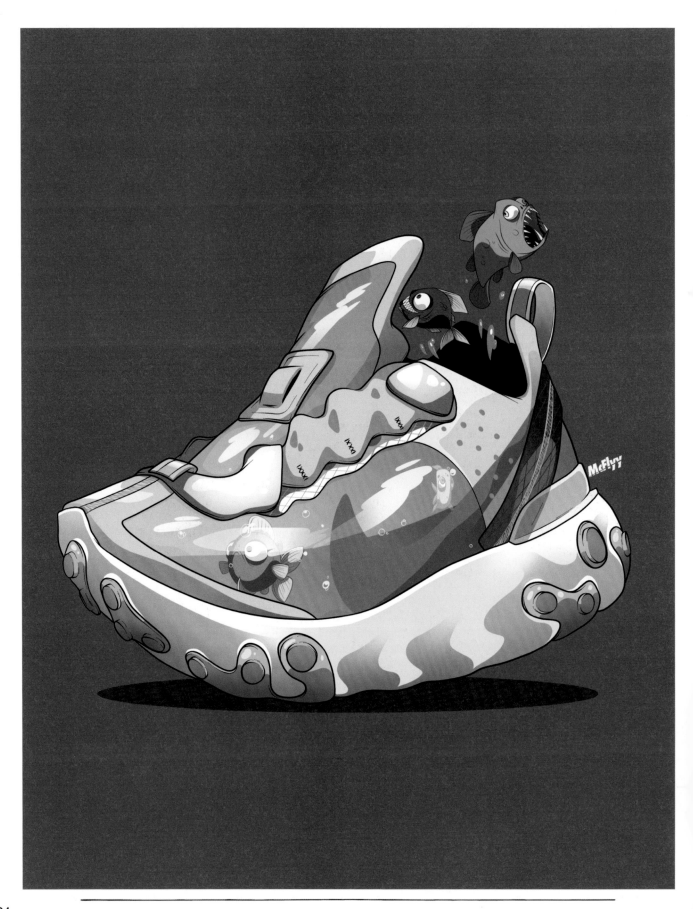

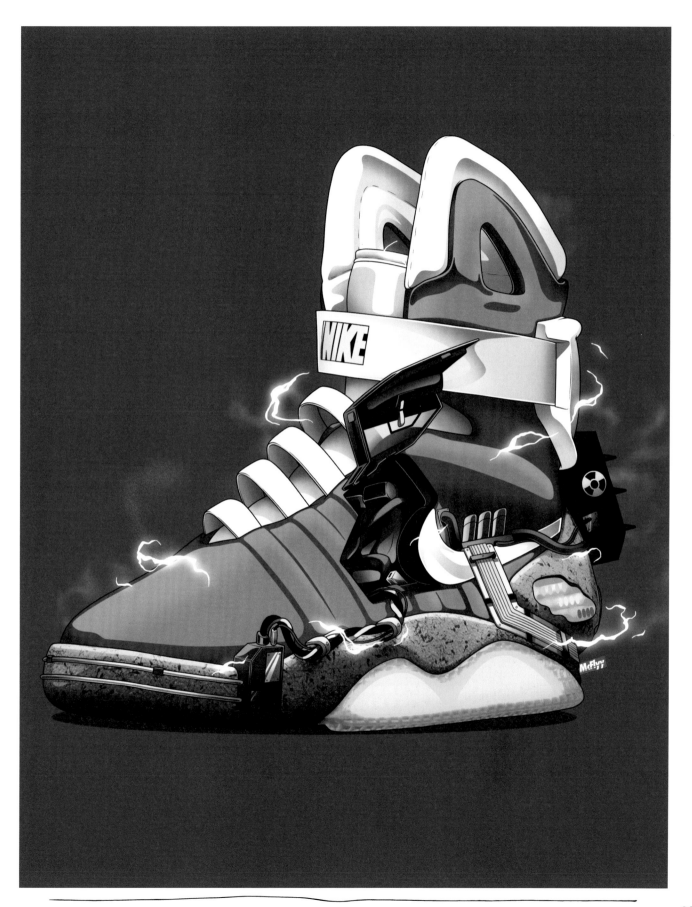

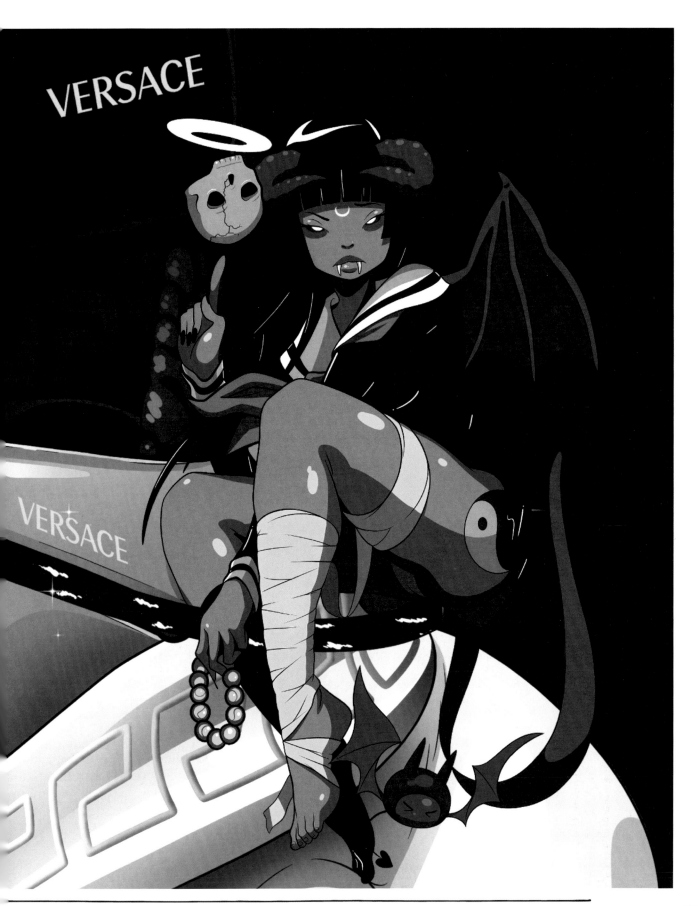

JERSEY CITY, NJ

CHRISTOPHER MINESES

Like most artists in this collection, Christopher Mineses was inspired by his love of sneakers at an early age—both from a design and cultural perspective.

It wasn't only the distinctive forms of the shoes that caught his eye. Mineses was also fascinated by the impact that a shoe can have, from a first impression one makes with a person to a mass market cultural phenomenon.

It is from these two perspectives that Mineses approaches his digital illustrations. His earliest artistic impression was made by late-90s animated sensation Dragon Ball Z, which is evident in his anime-inspired creations.

Christopher's unique take on the genre is used to both give his basketball and hip-hop idols their own heroic imagery, and to celebrate the commerce that drives the culture with his take on magazine advertisements.

WWW.CHRISTOPHERMINESES.WIXSITE.COM/CMINESES

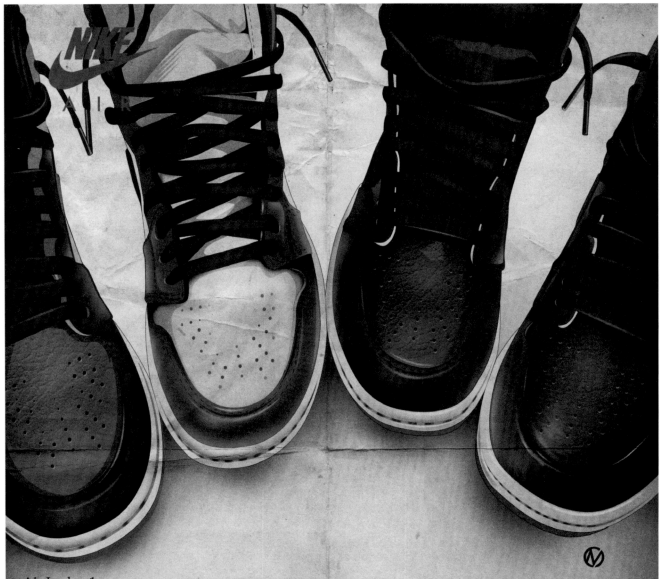

Air Jordan 1

ANTI-GRAVITY MACHINES.

Modern sneaker culture had its roots in the air; that is, the original Air Jordan
that released in 1985. Nike, and subsequently the Jordan Brand, has honored
this iconic silhouette numerous times since with releases of the Retro 1.

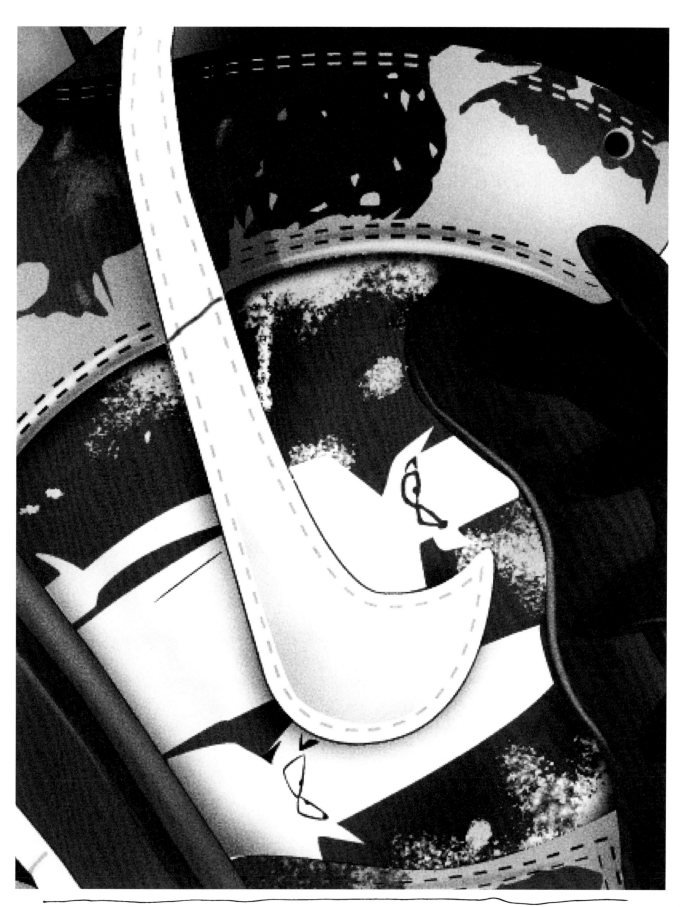

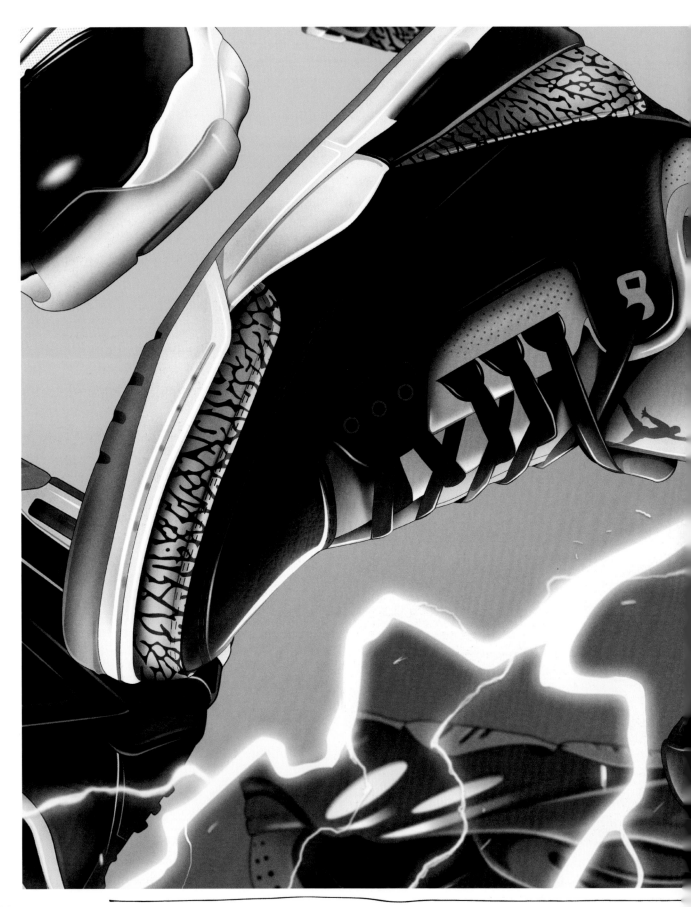

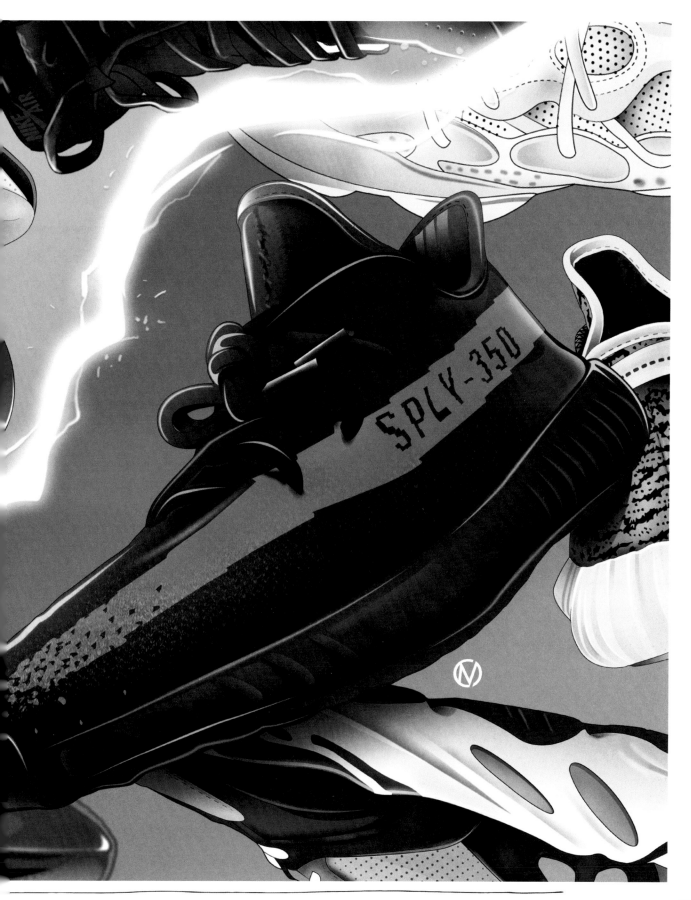

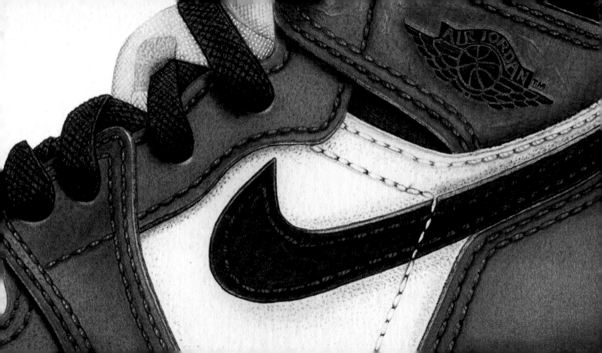

STE PH

MOR R IS

MANCHESTER, UK

The first drawings are the ones preserved in caves by our earliest human ancestors. It wasn't until the European Renaissance era (1530-1550) that drawing was regarded as an art form. Centuries later, contemporary artists are mastering the art of pencil drawing like never before and creating works so life-like it's almost impossible to tell them from apart from a photograph.

Manchester, UK, Steph Morris memorializes her love of sneakers by painstakingly and intricately recreating them with her pencil. With every shoe she chooses, Morris commemorates its life story through the fine details she's able to recreate. Mastering what appears to be light shining down on the leather toe box of a J1, or how each stitch of thread sewn in a New Balance seems to beg for our attention, her skill is truly a marvel.

The patient and meditative approach to her craft seems the perfect antidote to the cacophonous hype that surrounds sneaker culture. Her works are able to instill a wave of deafening silence that forces you to stop and look deeper.

WWW.STEPHFMORRIS.COM

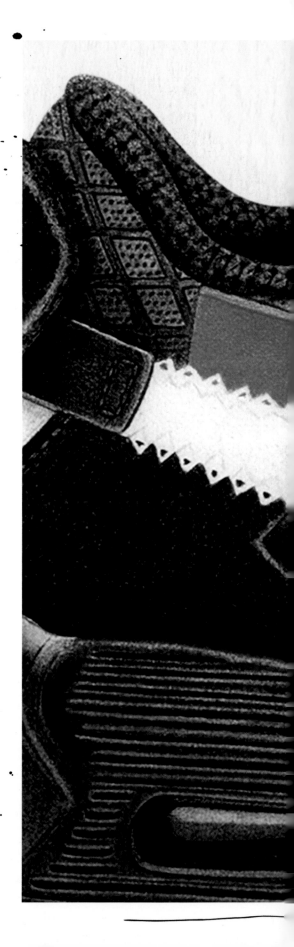

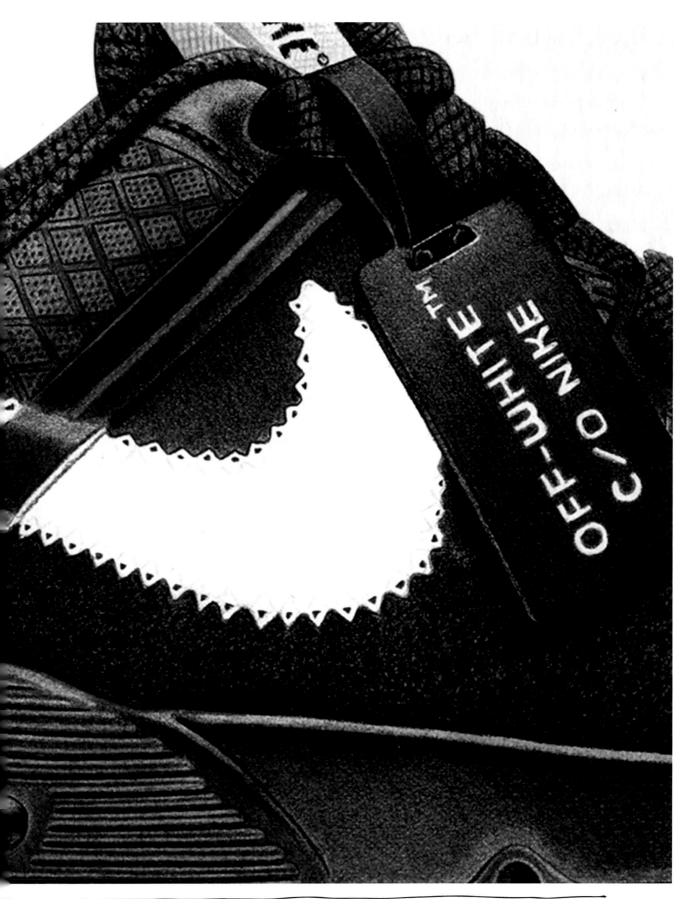

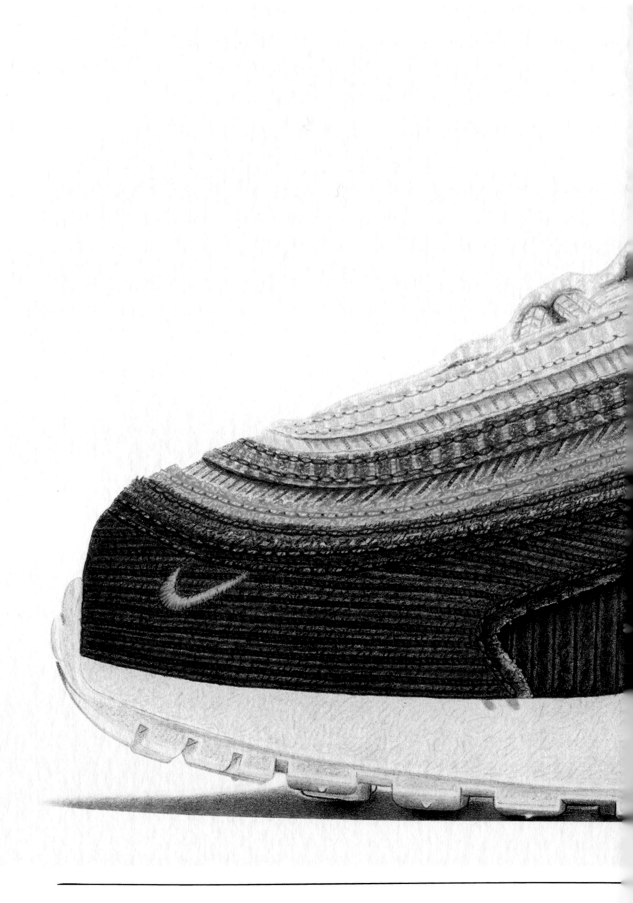

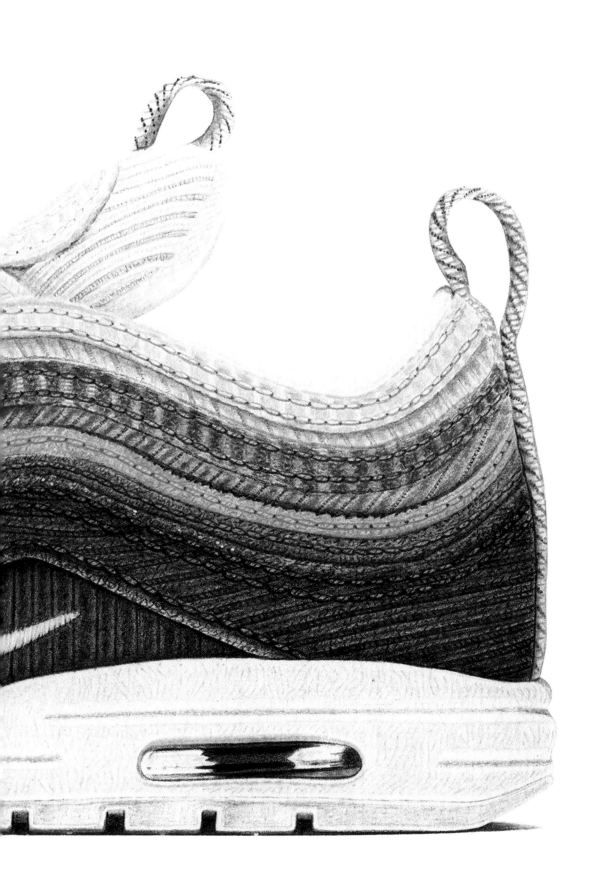

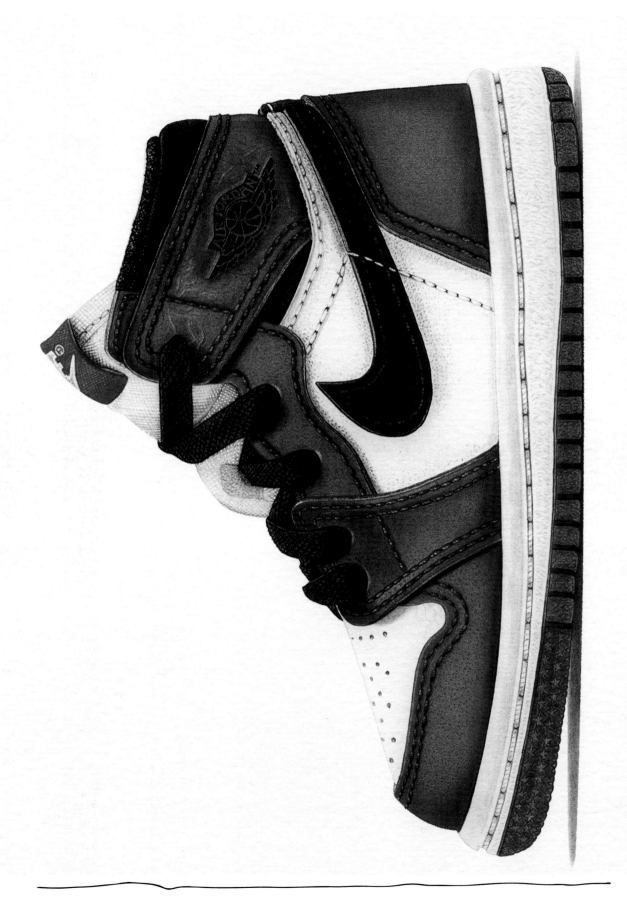

RO

RO

LOS ANGELES, CA

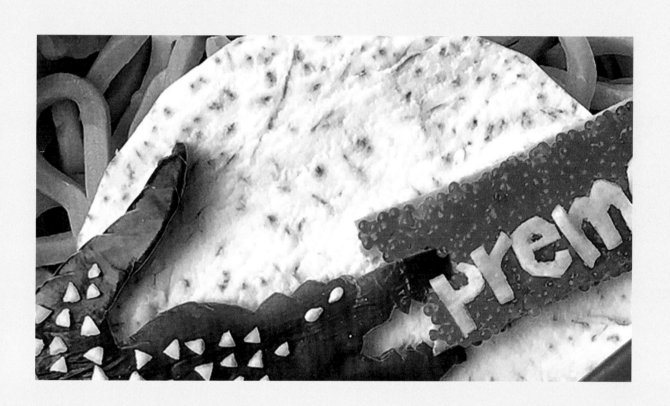

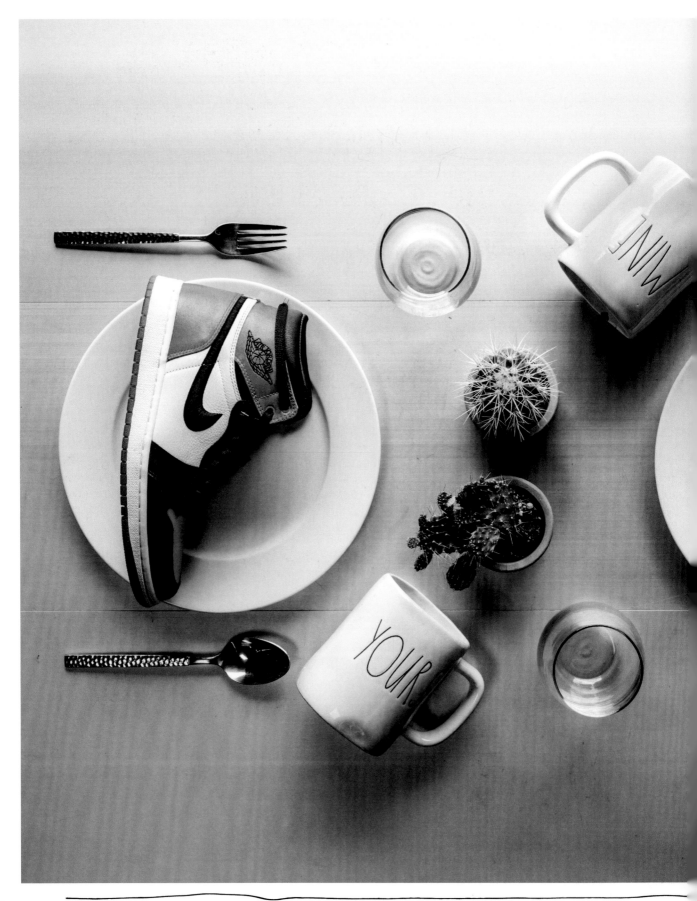

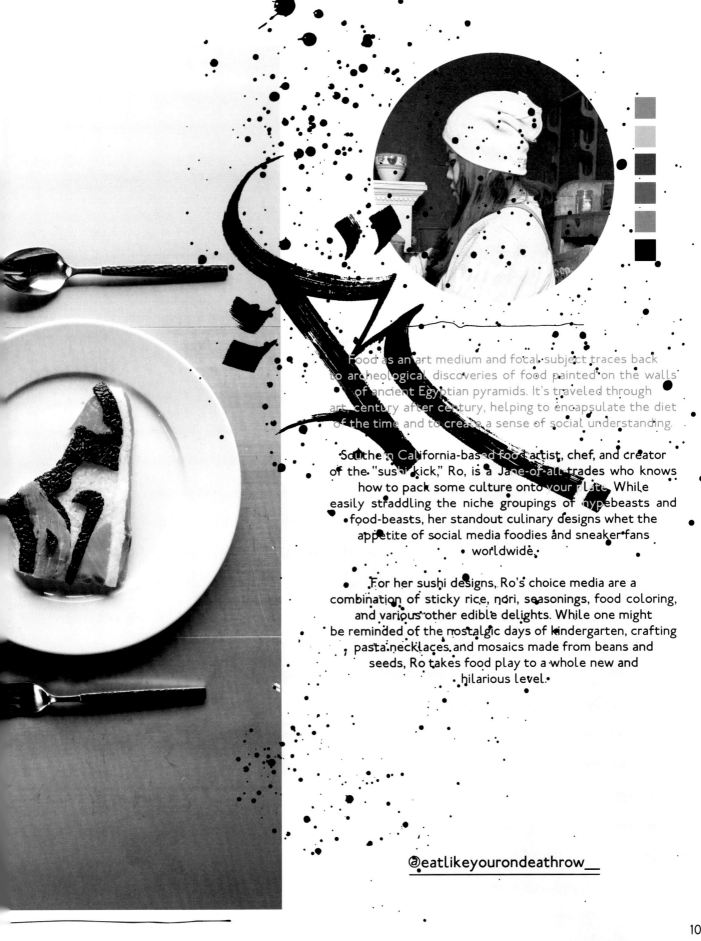

Food as an art medium and focal subject traces back to archeological discoveries of food painted on the walls of ancient Egyptian pyramids. It's traveled through art, century after century, helping to encapsulate the diet of the time and to create a sense of social understanding.

Southern California-based food artist, chef, and creator of the "sushi kick," Ro, is a Jane-of-all-trades who knows how to pack some culture onto your plate. While easily straddling the niche groupings of hypebeasts and food-beasts, her standout culinary designs whet the appetite of social media foodies and sneaker fans worldwide.

For her sushi designs, Ro's choice media are a combination of sticky rice, nori, seasonings, food coloring, and various other edible delights. While one might be reminded of the nostalgic days of kindergarten, crafting pasta necklaces and mosaics made from beans and seeds, Ro takes food play to a whole new and hilarious level.

@eatlikeyourondeathrow__

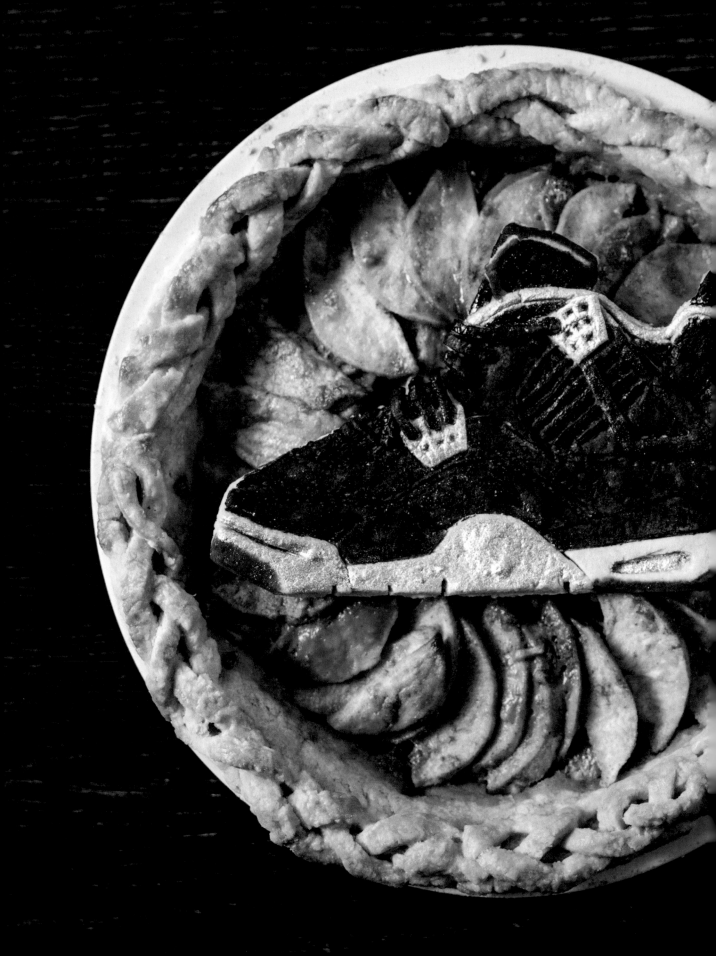

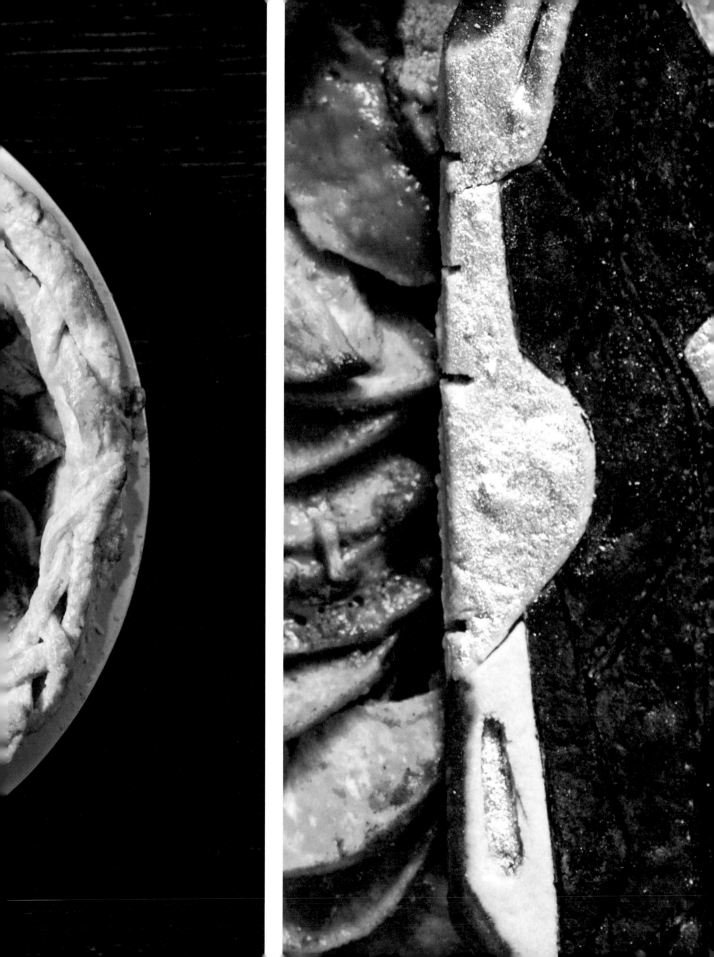

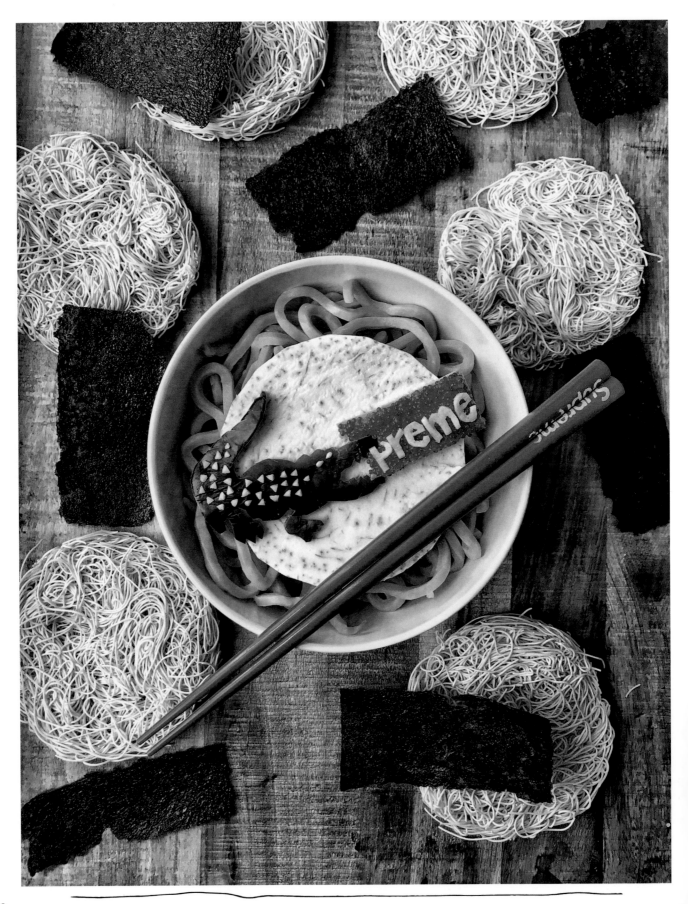

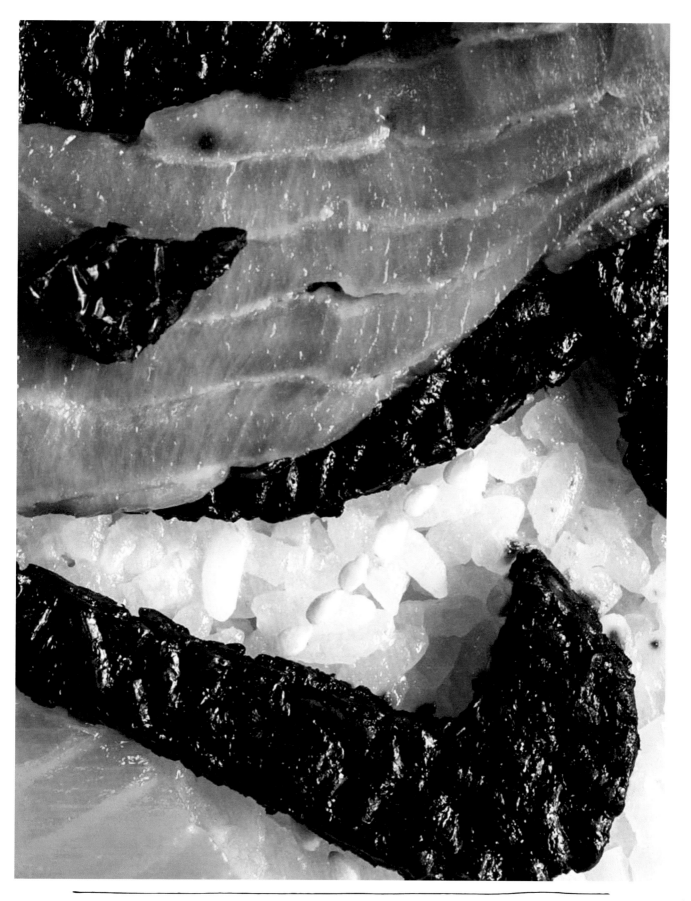

CHRISTOPHE ROBERTS

ROBERTS

CHRIS TOP HE

BROOKLYN, NY

Most artists are naturally drawn to a specific medium: painters to canvas, sculptors to bronze, graffiti artists to just about anything.

Visual artist Christophe Roberts chose his medium—sneaker boxes—while growing up on the North Side of Chicago in the Jordan era. He took inspiration from sports culture and hip-hop, and - with the help of his art teacher aunt turned his childhood love of chopping up paper plates and turning them into UFOs into the fine art he creates today.

Roberts has had a front-row seat to the process by which mainstream culture draws from sneaker culture: "The things that were widely accepted by street culture, the ghettos of America, the underground scene—culturally, artistically, visually—became more attractive to the people above ground because of how much substance and storytelling is related to a pair of kicks."

Storytelling is a deep vein through Roberts' work. He riffs on the similarities between the hip-hop crews he ran with in Chicago and the tribes his ancestors in Africa belonged to. He further references African folklore via the animal forms—big cats and birds of prey—that he favors in his shoebox sculptures.

WWW.CHRISTOPHEROBERTS.COM

"MY WORK IS A MODERN INTERPRETATION OF WHAT MY ANCESTORS WERE DOING BEFORE ME, FROM AFRICA TO CHICAGO."

–CHRISTOPHE ROBERTS

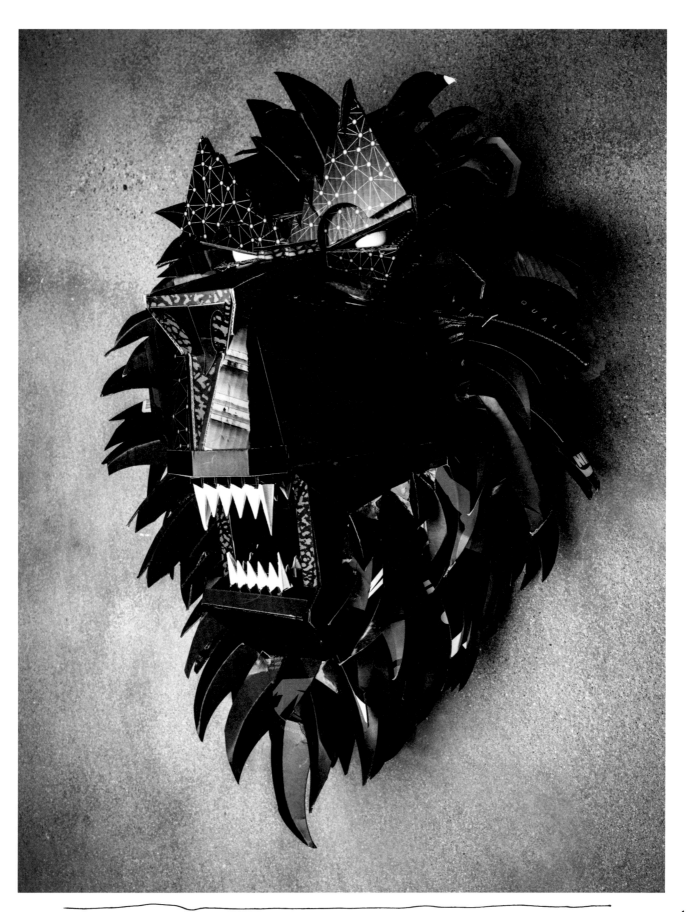

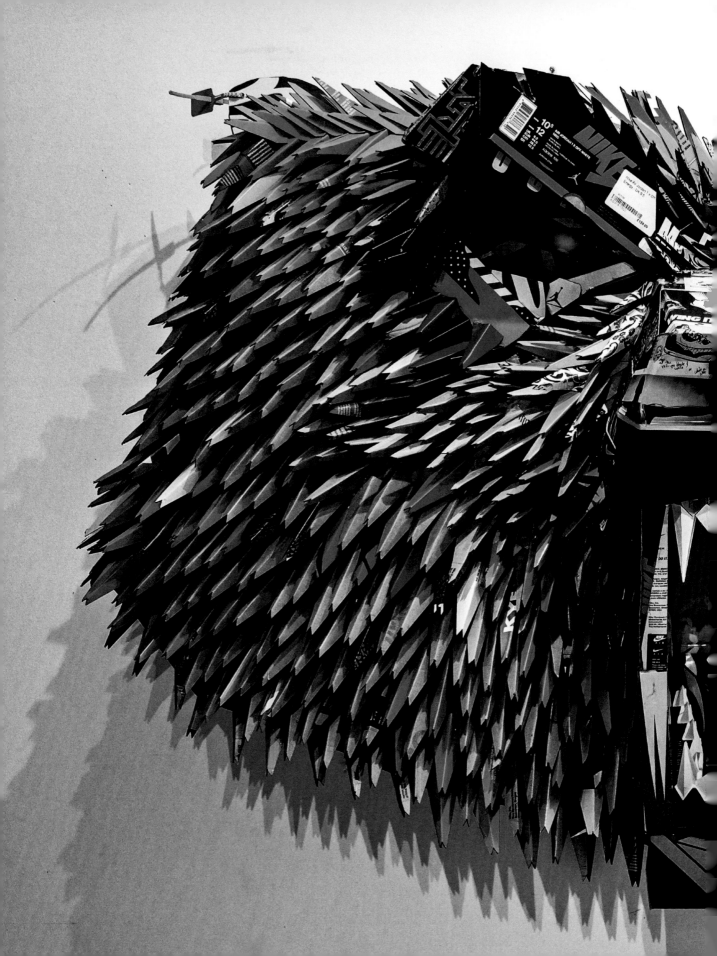

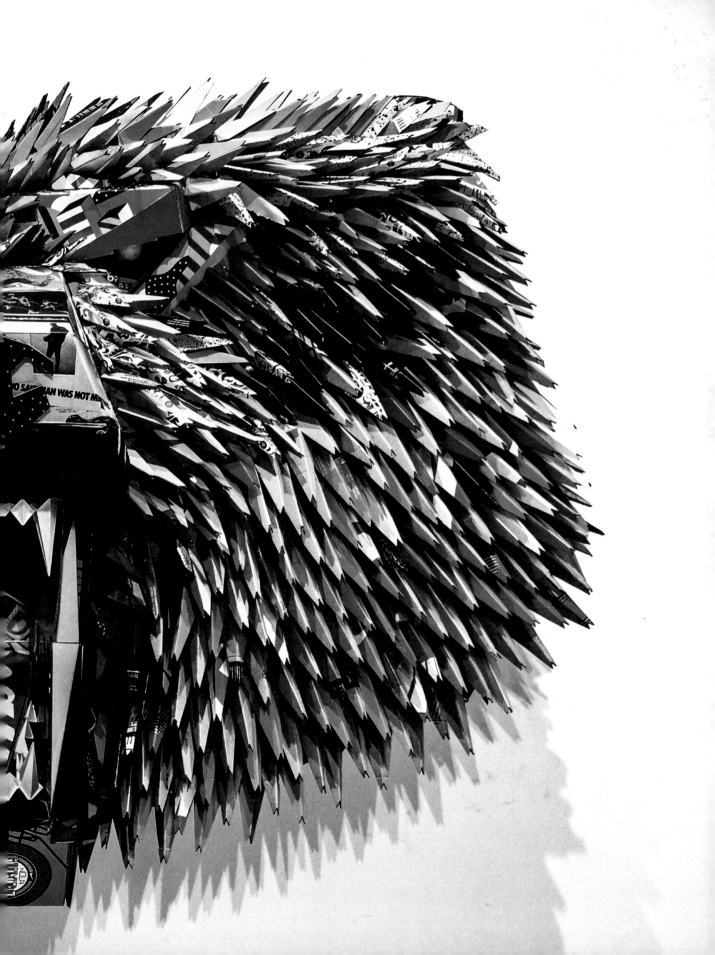

ONCE YOU ZEN AS AN YOU

YOUR AND YOUR AND

ARTIST UNDERSTAND WHY

PURPOSE AND THEN HERE HI N

YOU'RE VERY

DOWN THINK

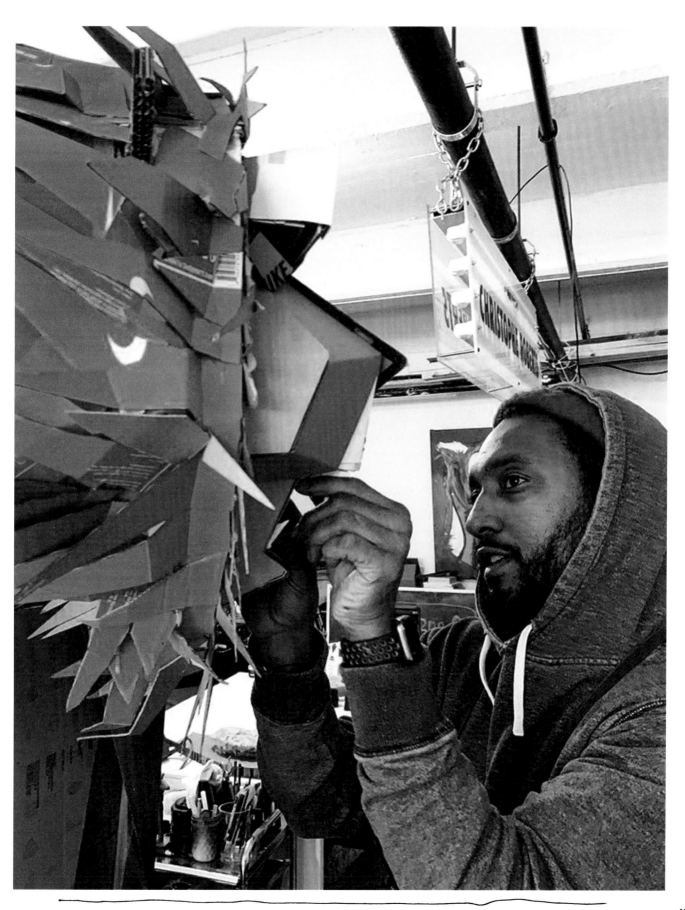

STOMPERHAUS

stOMP ERHAUS

LOS ANGELES, CA

Footwear design is an especially precise art form and proportion is king. That makes California sneaker illustrator and sculptor Aylmer Abrea aka STOMPERHAUS a kingslayer.

Abrea's "Stomperhaus" namesake is an amalgamation of two of his biggest art inspirations, the first being California artist and captain of the custom car craze in the 50s and 60s, Ed "Big Daddy" Roth. Roth was known for exaggerated characters and car features, and once depicted a 1956 Ford Stomper that had huge back wheels and jumbo, over-the-top attributes. The third syllable of his name came from the fact that Abrea was influenced by the German Bauhaus movement. Bauhaus spoke to the lifelessness of modern manufacturing, and anxieties on the art world dying out.

The Bauhaus aimed to reunite fine art and functional design, creating practical objects with the soul of artworks.

In gazing at Stomperhaus' larger than life creations, we find that he is perhaps imbuing them with the same energy expended to both create and acquire these sneakers.

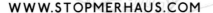

WWW.STOMPERHAUS.COM

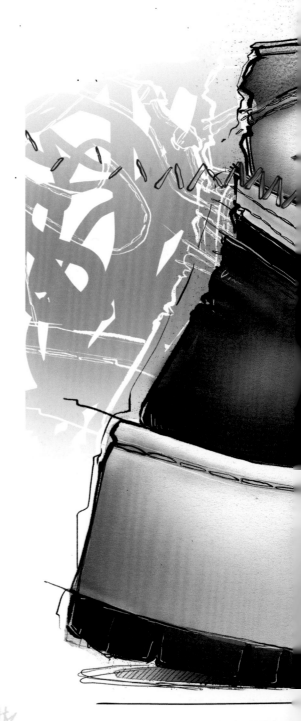

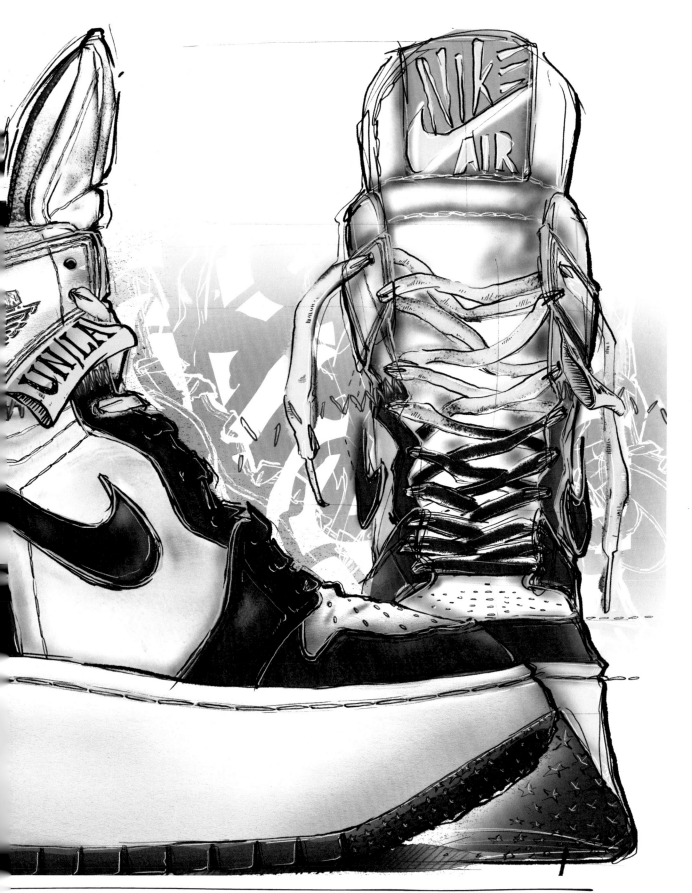

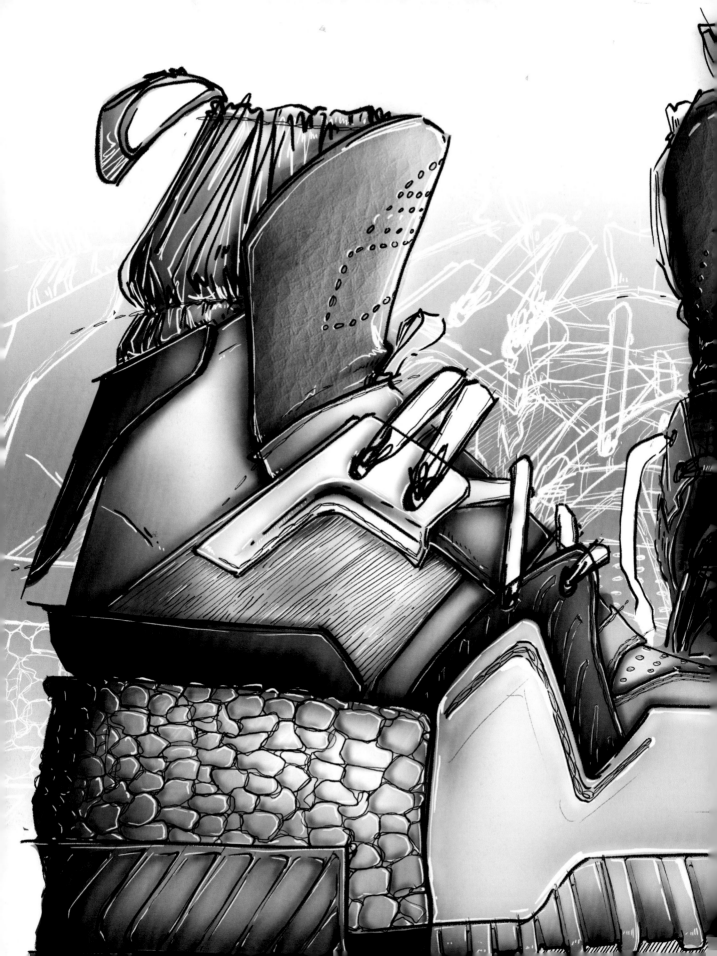

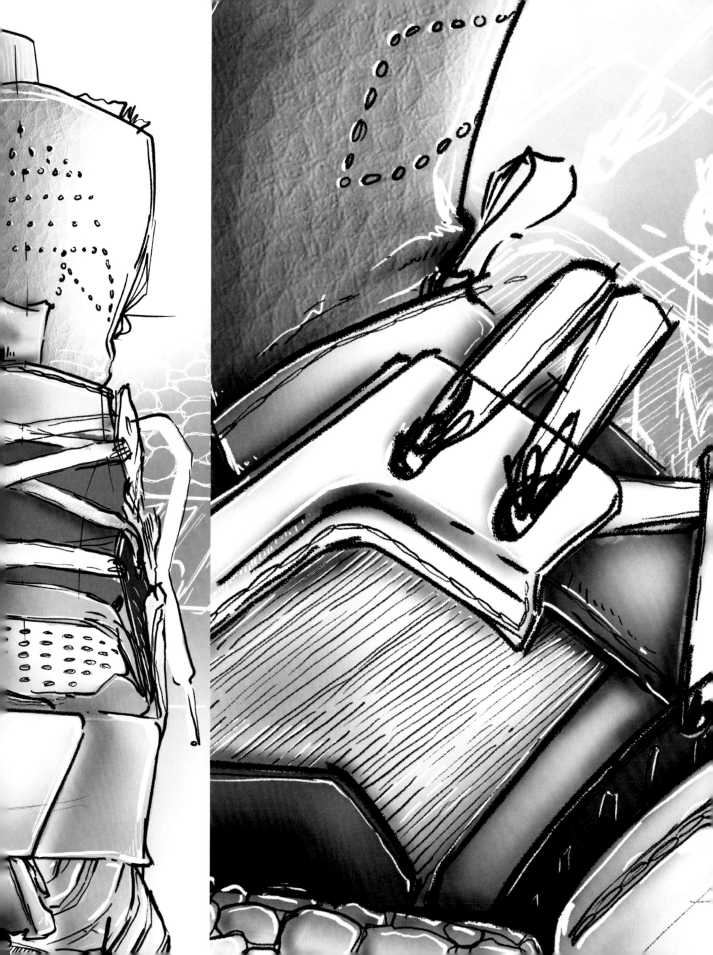

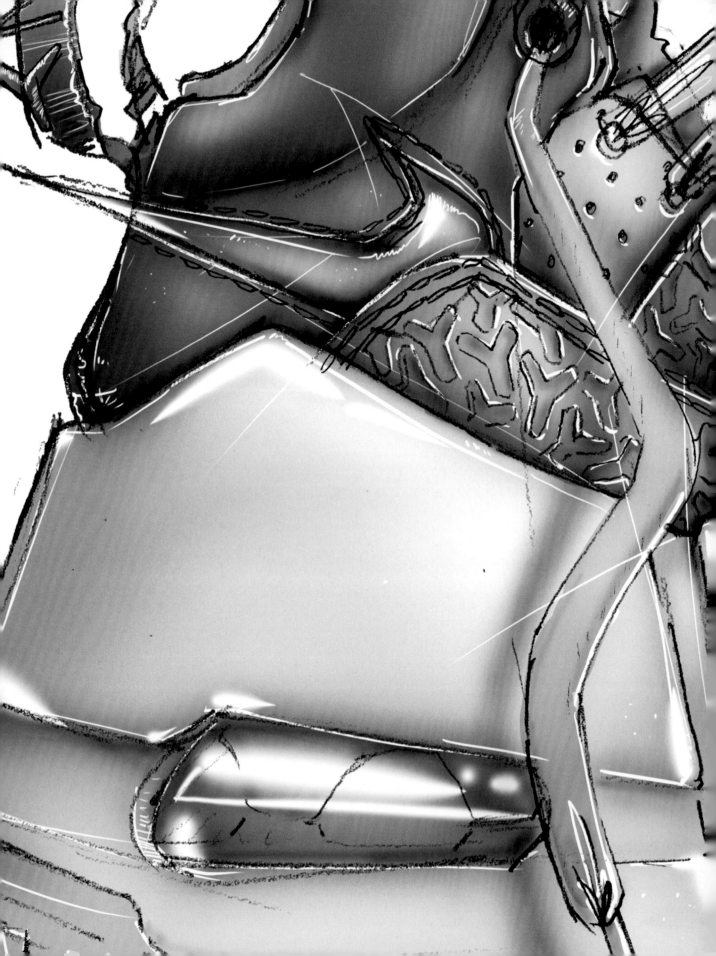

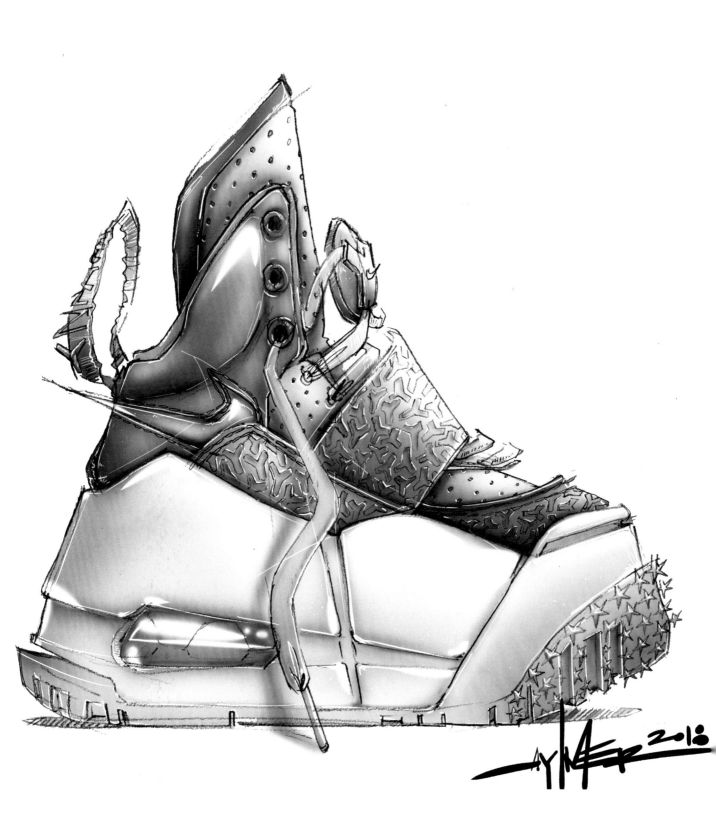

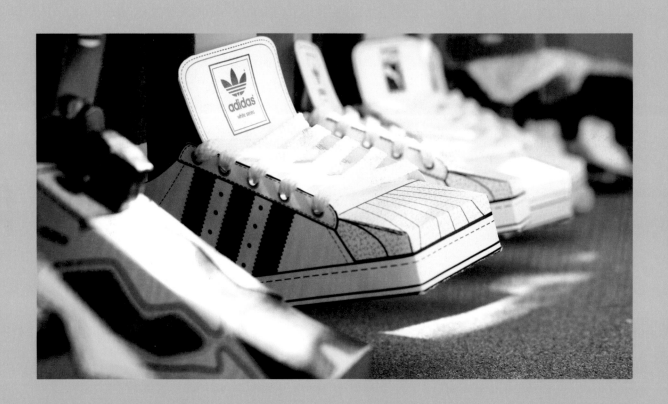

TOYGAMI

LOS ANGELES, CA

TOYGAMI

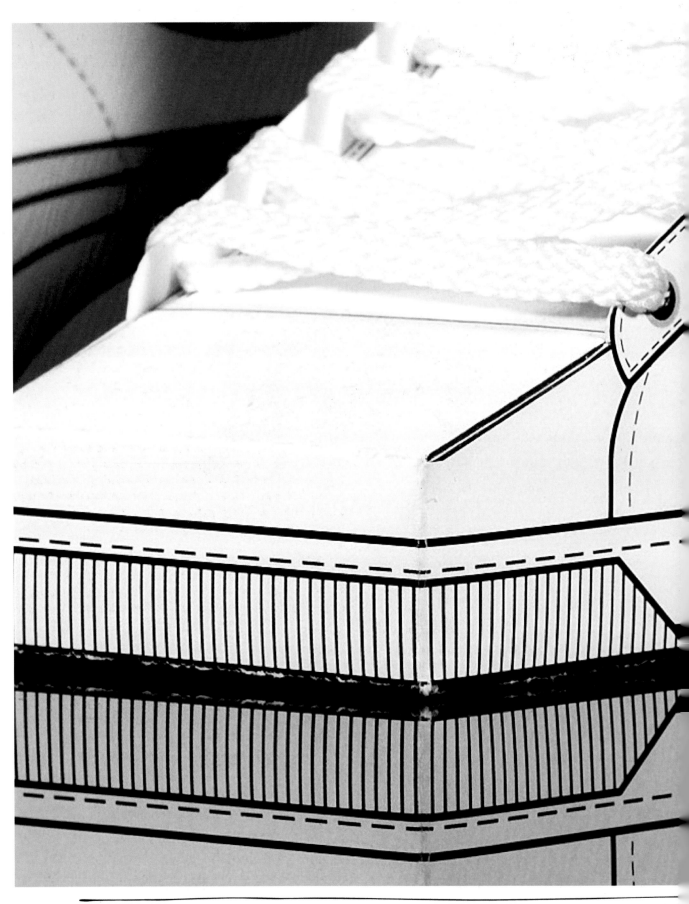

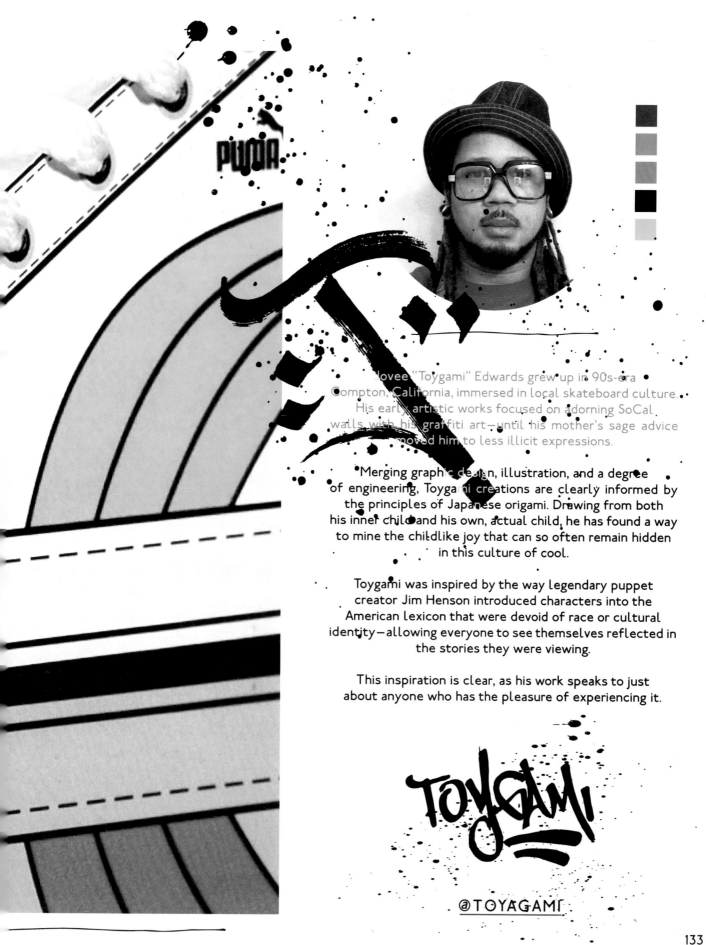

Jovee "Toygami" Edwards grew up in 90s-era Compton, California, immersed in local skateboard culture. His early artistic works focused on adorning SoCal walls with his graffiti art—until his mother's sage advice moved him to less illicit expressions.

Merging graphic design, illustration, and a degree of engineering, Toygami creations are clearly informed by the principles of Japanese origami. Drawing from both his inner child and his own, actual child, he has found a way to mine the childlike joy that can so often remain hidden in this culture of cool.

Toygami was inspired by the way legendary puppet creator Jim Henson introduced characters into the American lexicon that were devoid of race or cultural identity—allowing everyone to see themselves reflected in the stories they were viewing.

This inspiration is clear, as his work speaks to just about anyone who has the pleasure of experiencing it.

@TOYAGAMI

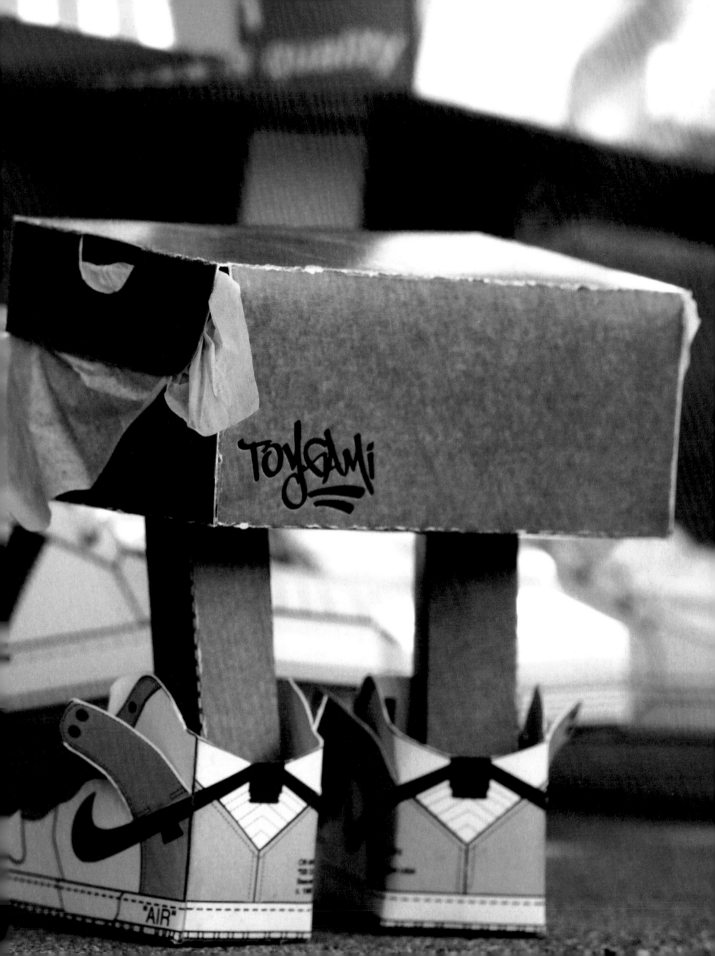

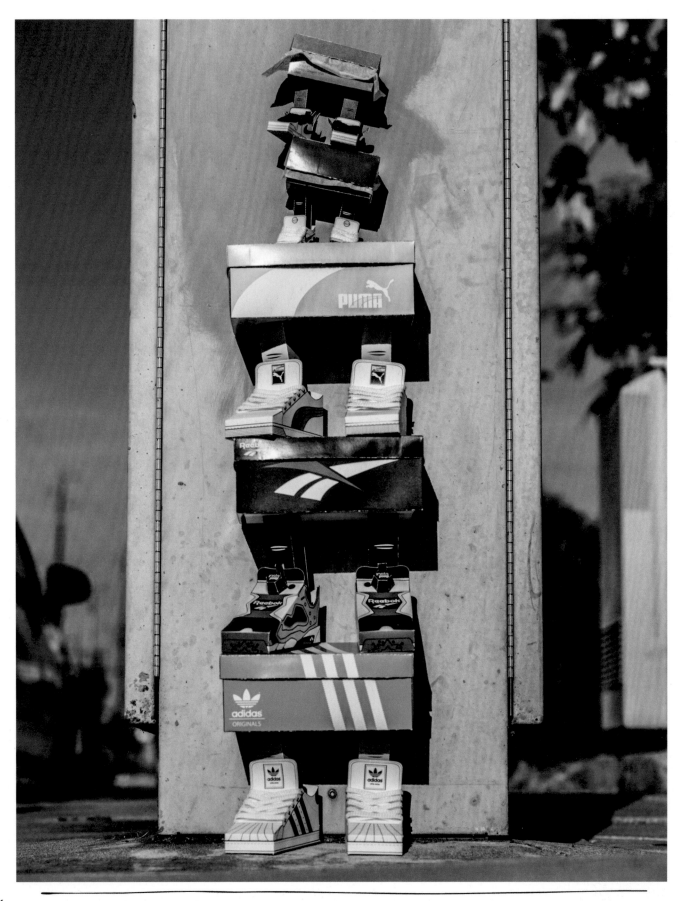

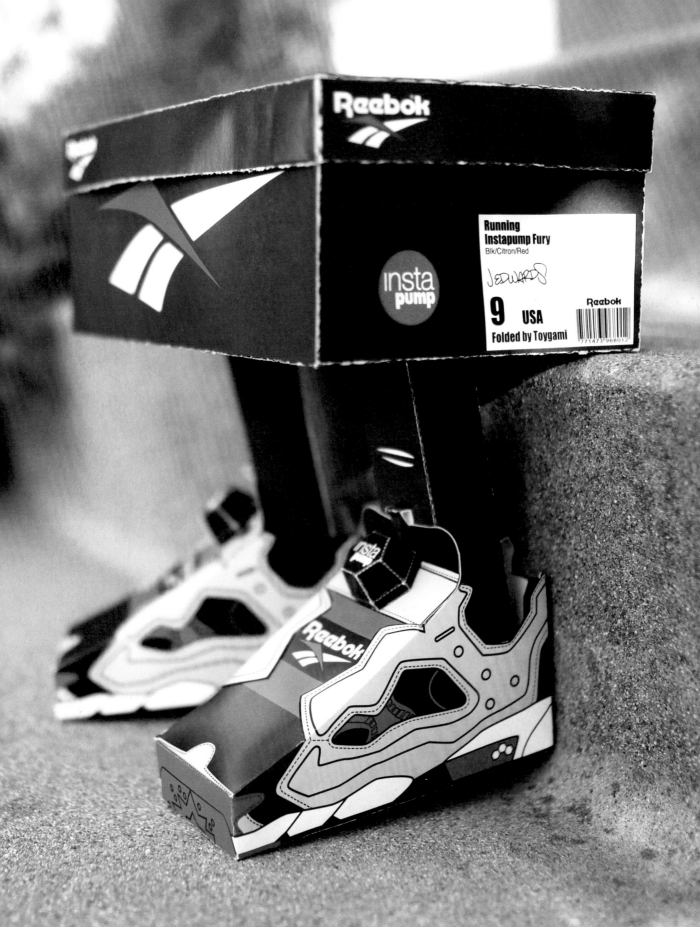

TR ACY

TRACY TUBERA

T UB ERA

PASADENA, CA

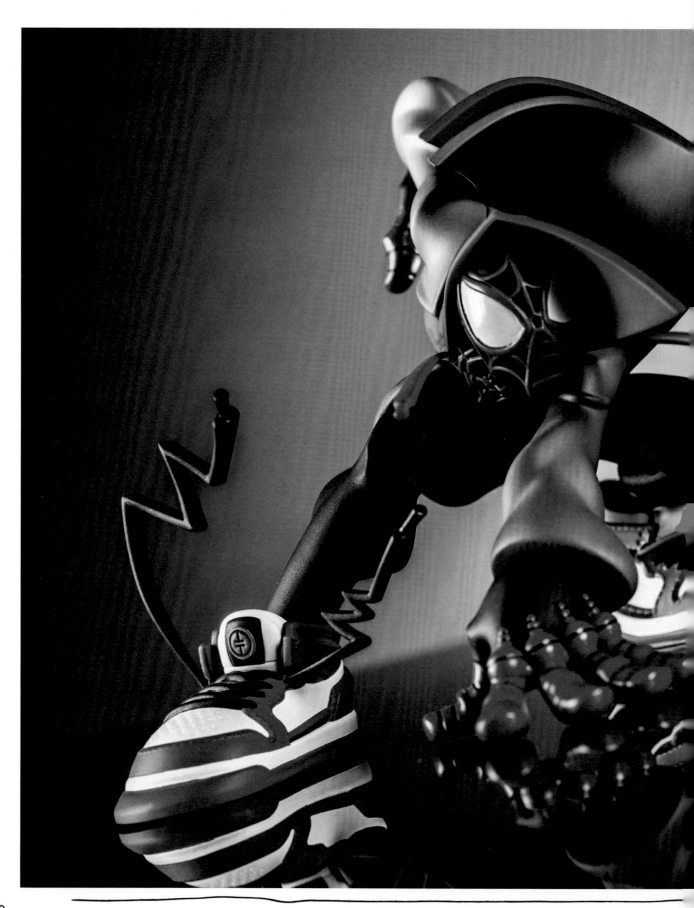

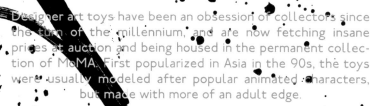

Designer art toys have been an obsession of collectors since the turn of the millennium, and are now fetching insane prices at auction and being housed in the permanent collection of MoMA. First popularized in Asia in the 90s, the toys were usually modeled after popular animated characters, but made with more of an adult edge.

Self-proclaimed "über illustrator supreme" Tracy Tubera has gone from a stint designing skate shoes to designing premium art toys for Sideshow Collectibles. It is a perfect melding of his skills and his passions for graffiti, anime, and comic book art.

A chance to put one's own spin on revered characters such as Spiderman, Black Panther, and Deadpool is pretty much a dream come true for any fan of the genre, and Tubera has made a name for himself with his dynamic, intricate creations.

Don't forget to peep the shoes, for they are far from an afterthought.

WWW.TRACYTUBERA.COM

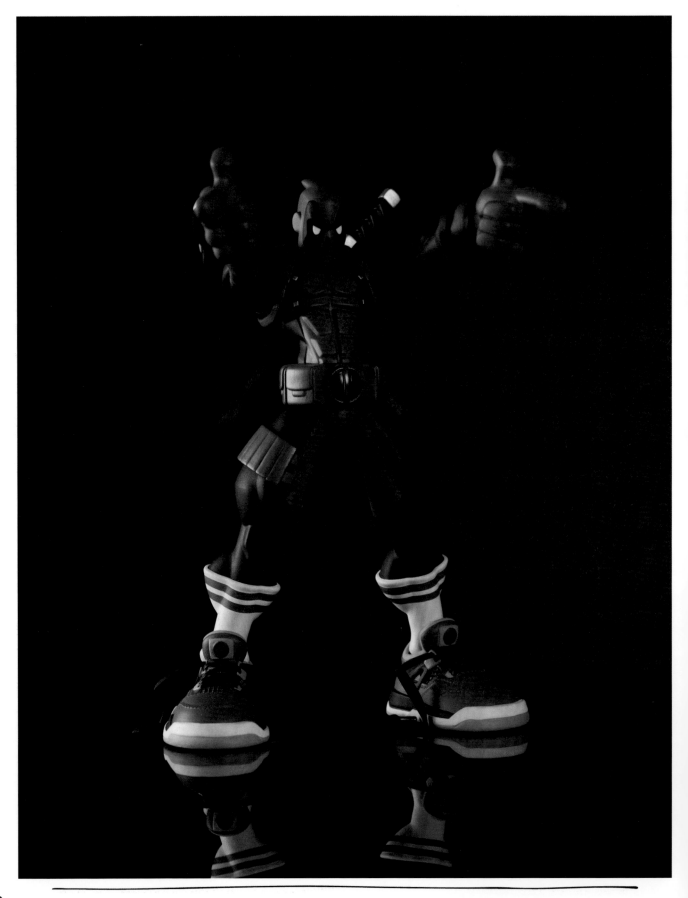

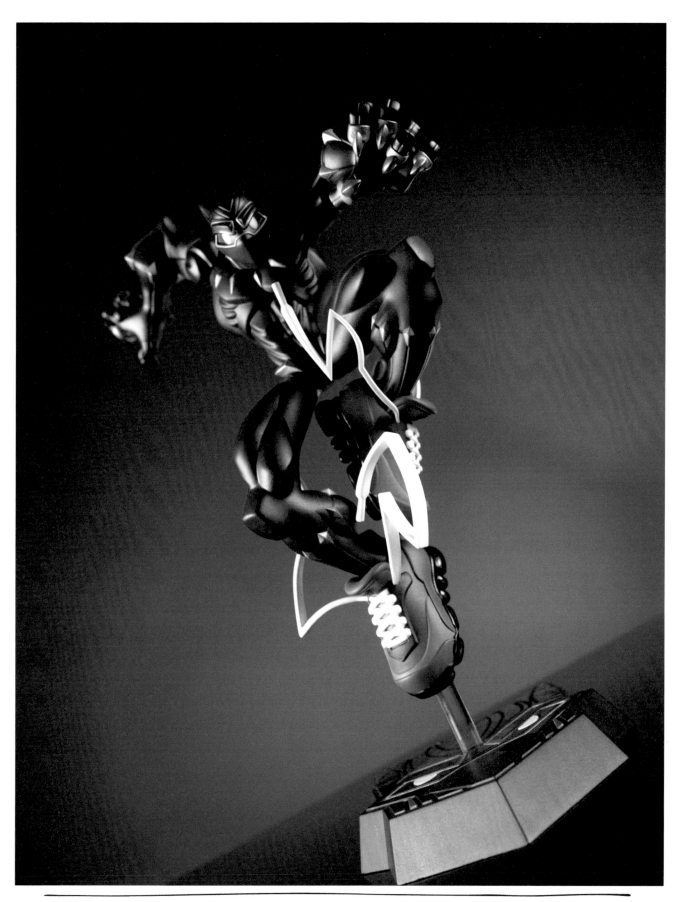

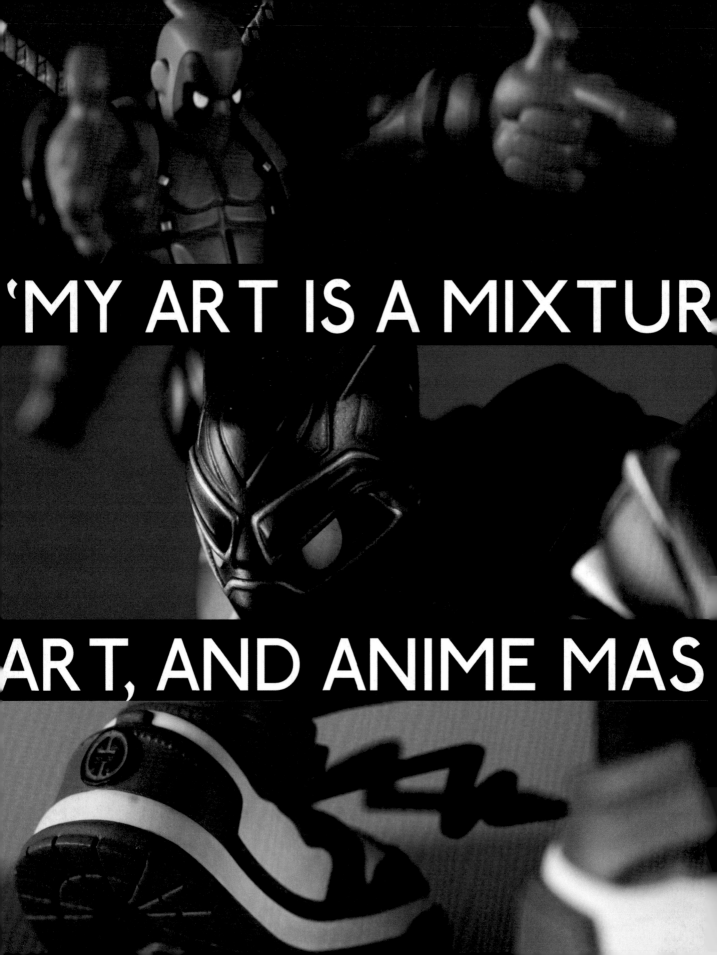

'MY ART IS A MIXTUR

ART, AND ANIME MAS

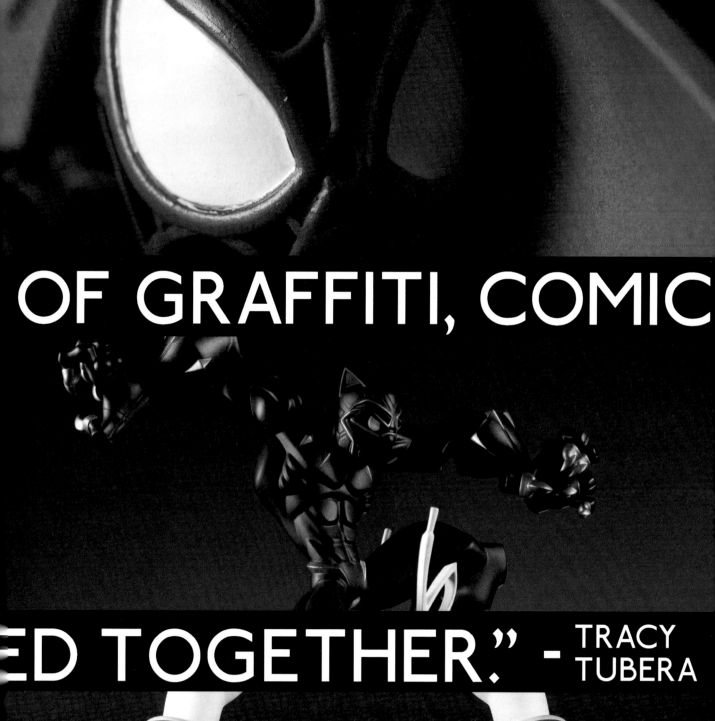

OF GRAFFITI, COMIC

ED TOGETHER." - TRACY TUBERA

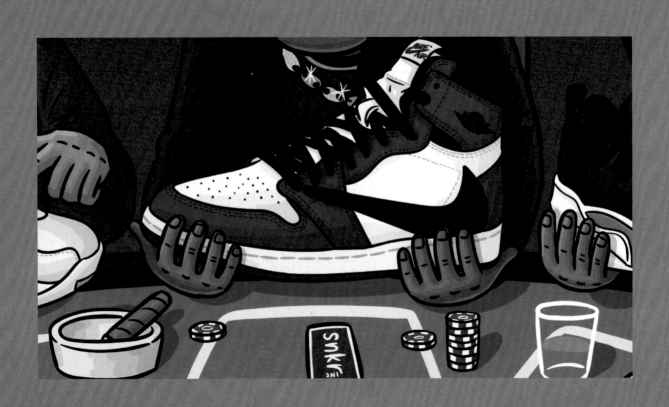

PARK TYSON

PAR K

T YS ON

SEOUL, REPUBLIC OF KOREA

PARK TYSON

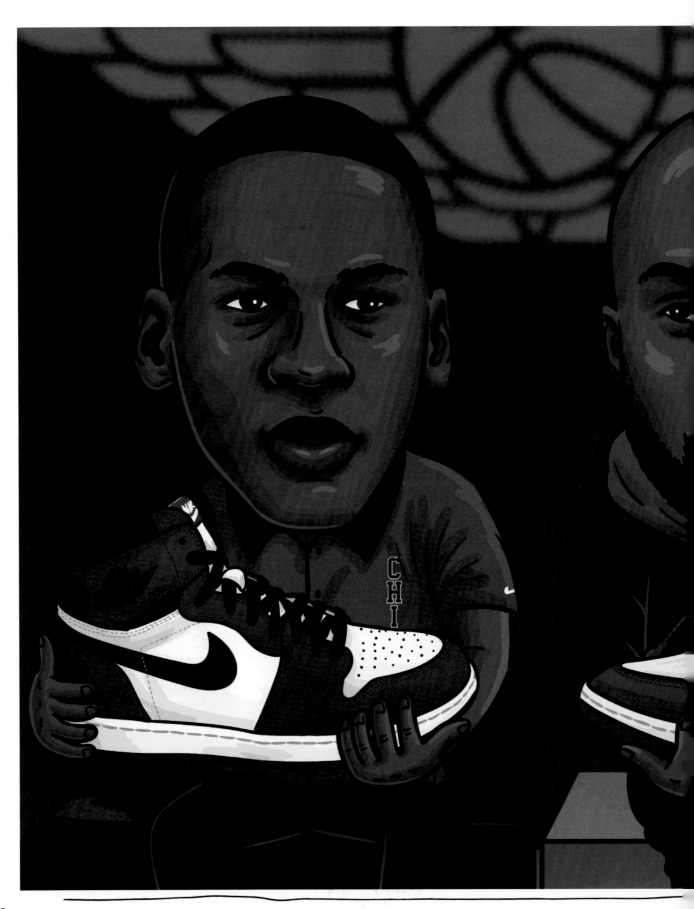

Caricature art has a long history, dating back to times when literacy was less common and drawings of public figures were used to convey any number of messages.

If it weren't for British artist James Gillray (1756–1815), Napoleon Bonaparte may not have gone down in history as the easily agitated, vertically challenged figure we have come to know. Caricature artists through the ages have been able to transcend language and boundaries, cutting to the heart of, or satirizing, a topic by drawing evocative images.

Hailing from Seoul in the Republic of Korea, illustrator Park Tyson pays homage to, and elevates the use of, caricature art by keeping it all about "the culture." It was his love for sneakers and the historical stories they were able to tell that inspired him to start creating his signature drawings. Every piece tells a clever story, winking and nodding to hip-hop and sports' most noteworthy topics of discussion. His illustrations are beguilingly accurate and bestow earnest and endearing qualities on these larger-than-life and seemingly untouchable, unknowable celebrities.

@parktyson

WWW.ROYALLIFECREW.COM

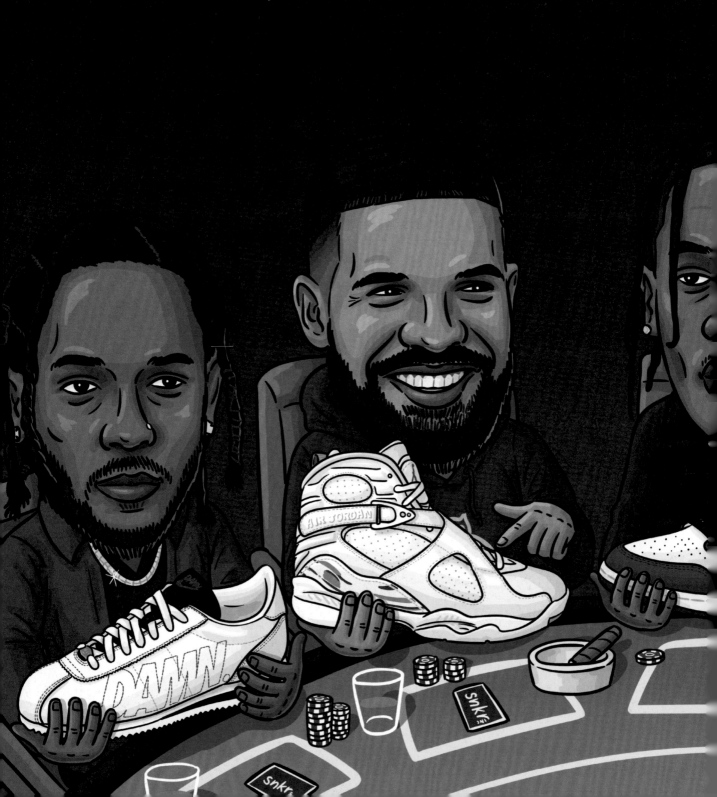

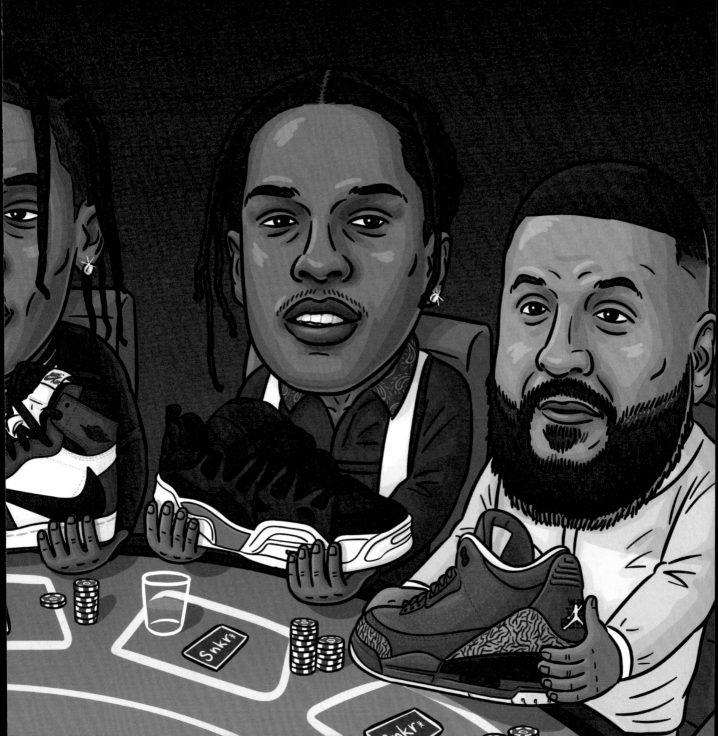

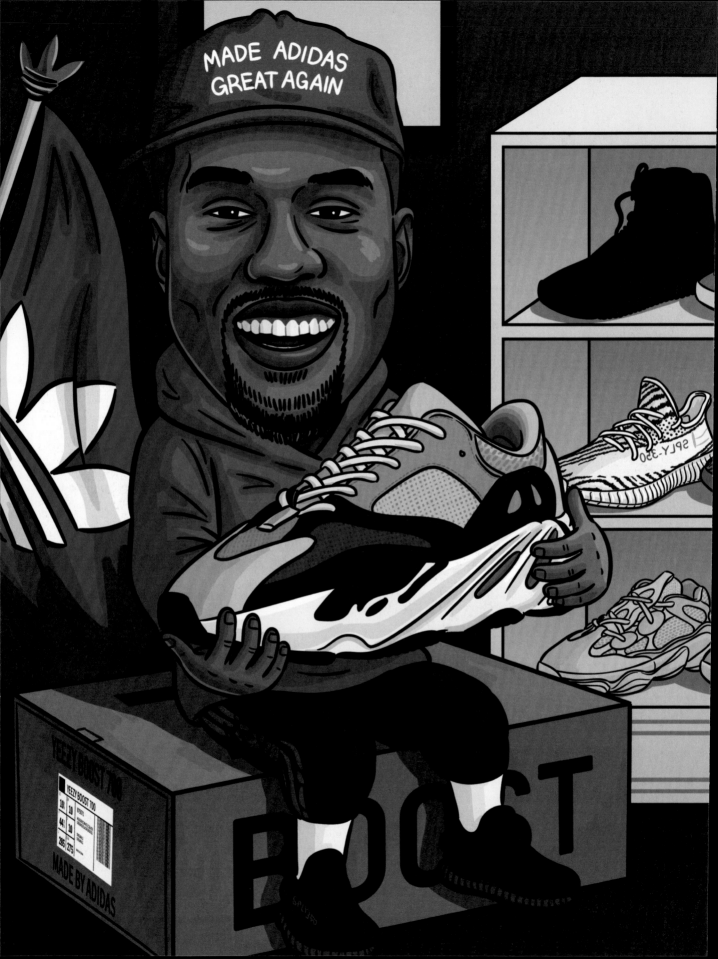

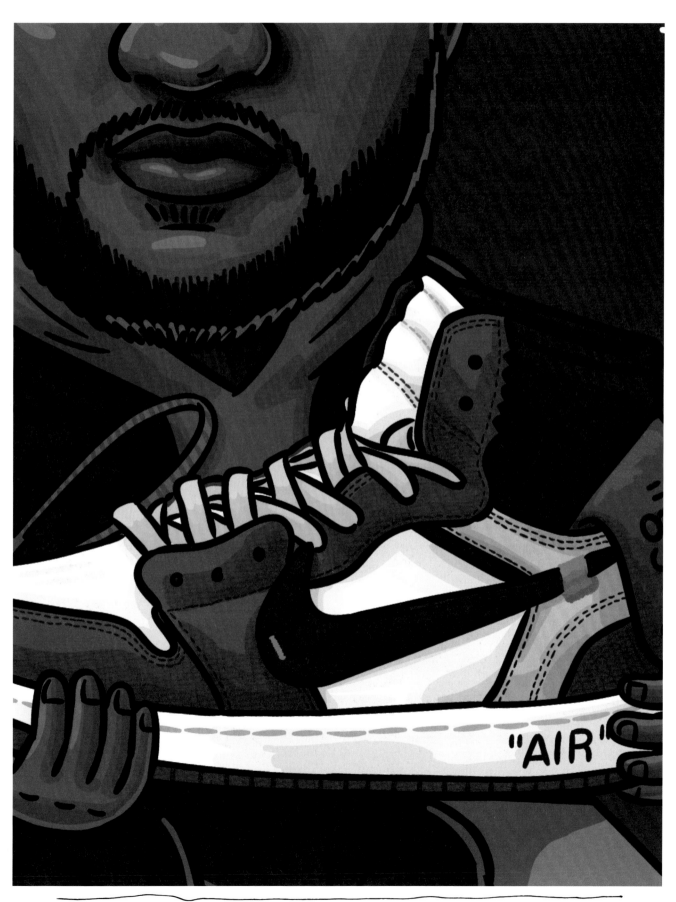

TOM YOO

T OM

OO

LOS ANGELES, CA

Y

TOM YOO

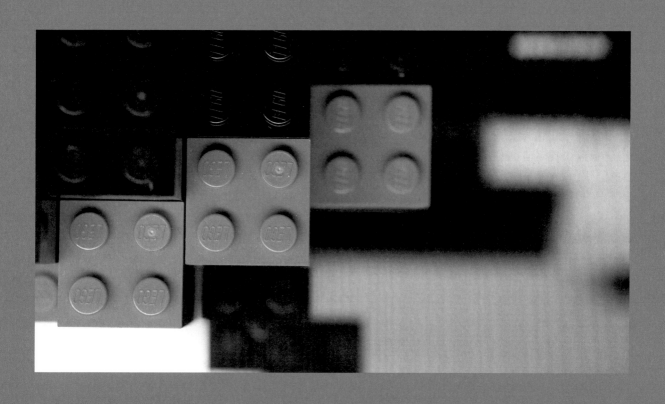

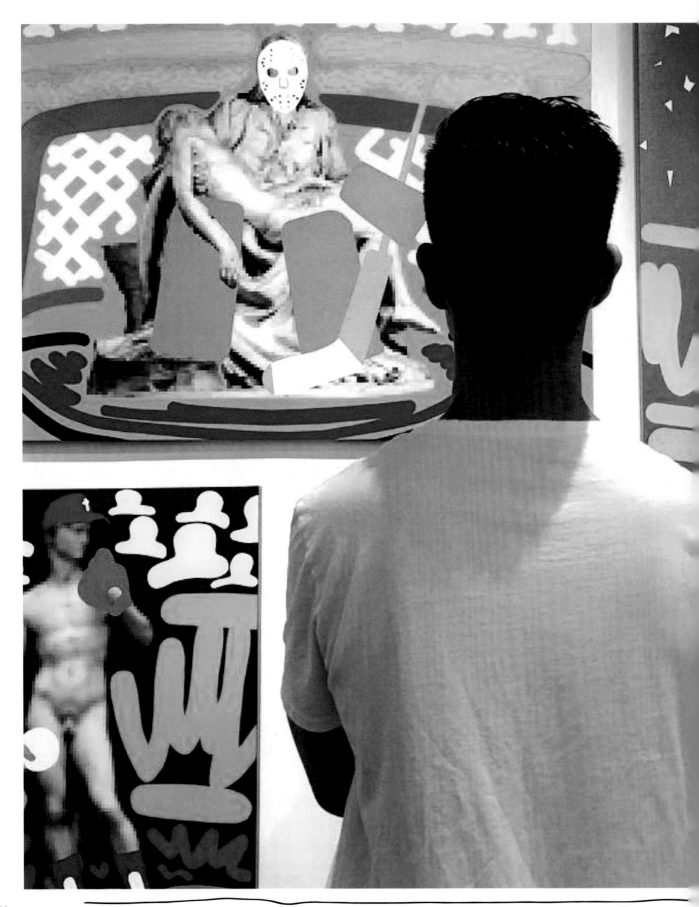

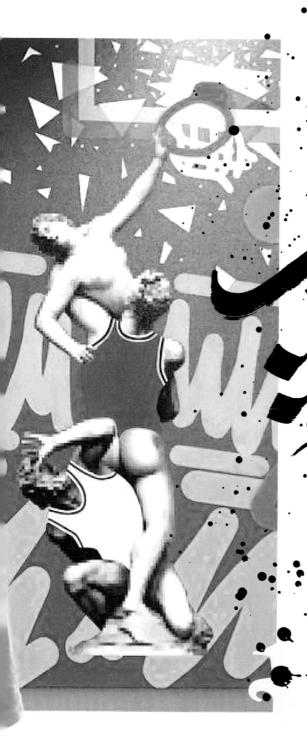

The artistic act of giving everyday items new life is nothing new—just look to the work of modern art heroes like Robert Rauschenberg, Marcel Duchamp, and Damien Hirst. Los Angeles-based artist Tom Yoo has found his muse in a material typically found scattered across the floors of kids' rooms around the globe.

Legos have been used to recreate all sorts of icons—from real-life monuments like the Eiffel Tower to dreamt-up spacecraft like the Millennium Falcon. Yoo has taken this beloved tradition, dialed it up several notches, and applied it to his own passion. Utilizing computer modeling programs, he builds larger-than-life sneaker sculptures that would make Lego creator Ole Christiansen proud.

Capturing the sinuous details of a sneaker using rectangular bricks would be a challenge in a world that hadn't already learned to view itself in 8-bit. Yoo uses that familiar cultural language to great effect in his scaled-up creations, and has since seen his work inspire many others to do the same.

𝕿
𝖄𝕺𝕺
𝕸

www.tomyoo23.com

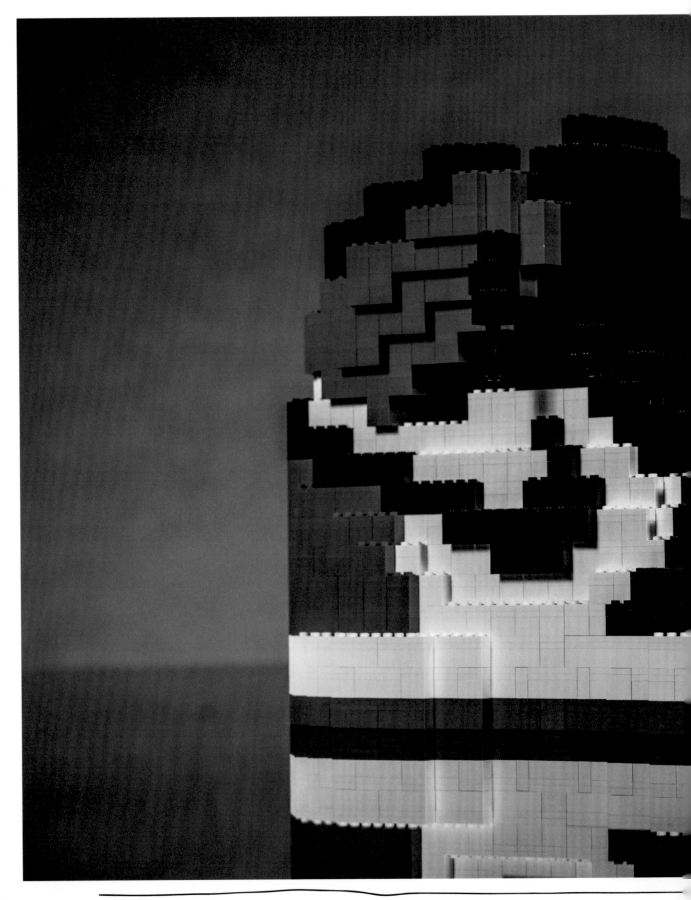

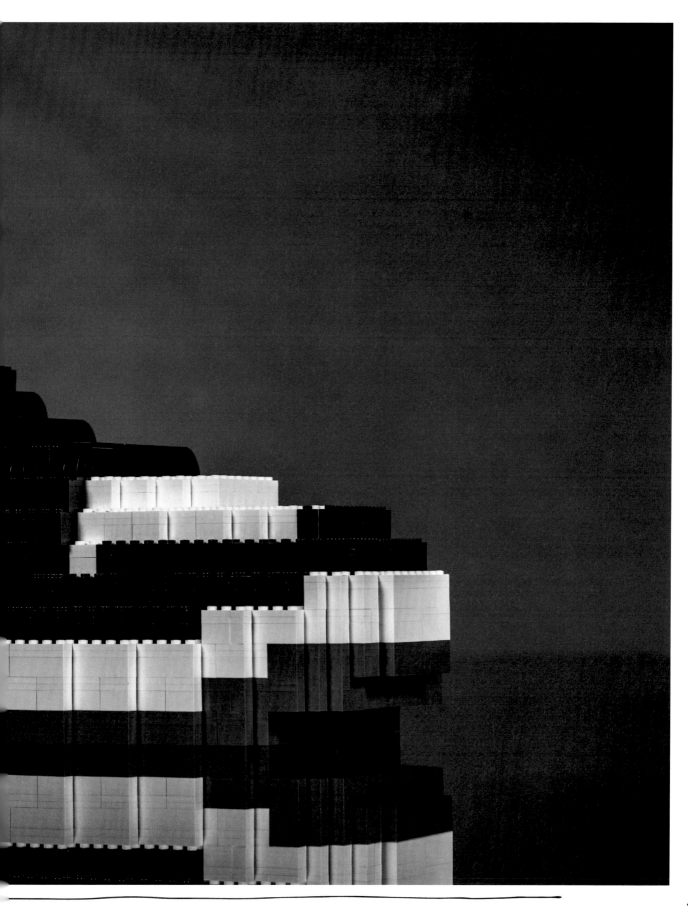

"ART IS JUST A REFLECTION OF WHO I AM. MY PASSIONS AND MY CULTURE. "

-TOM YOO

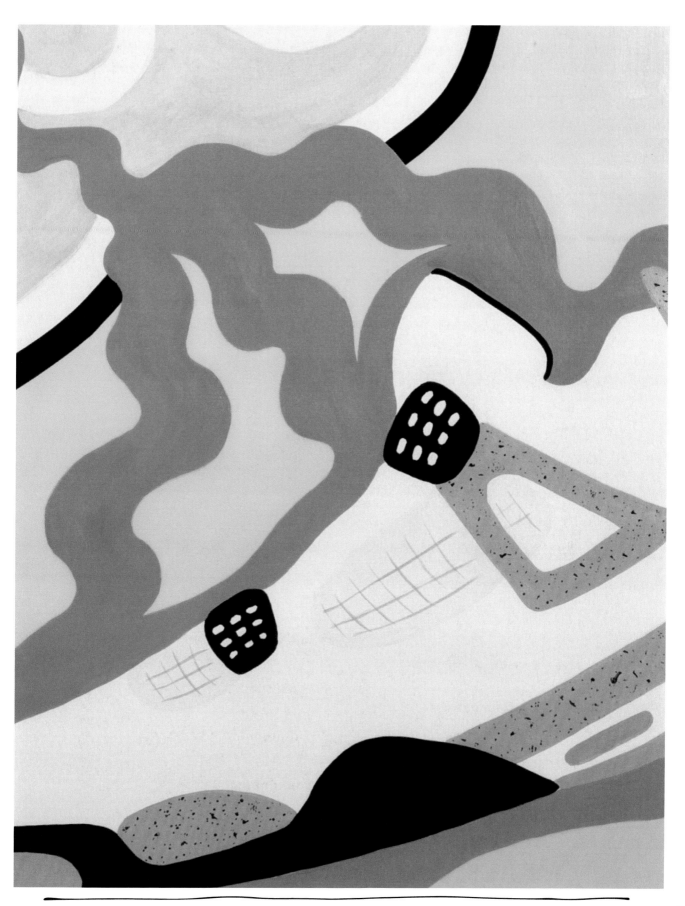

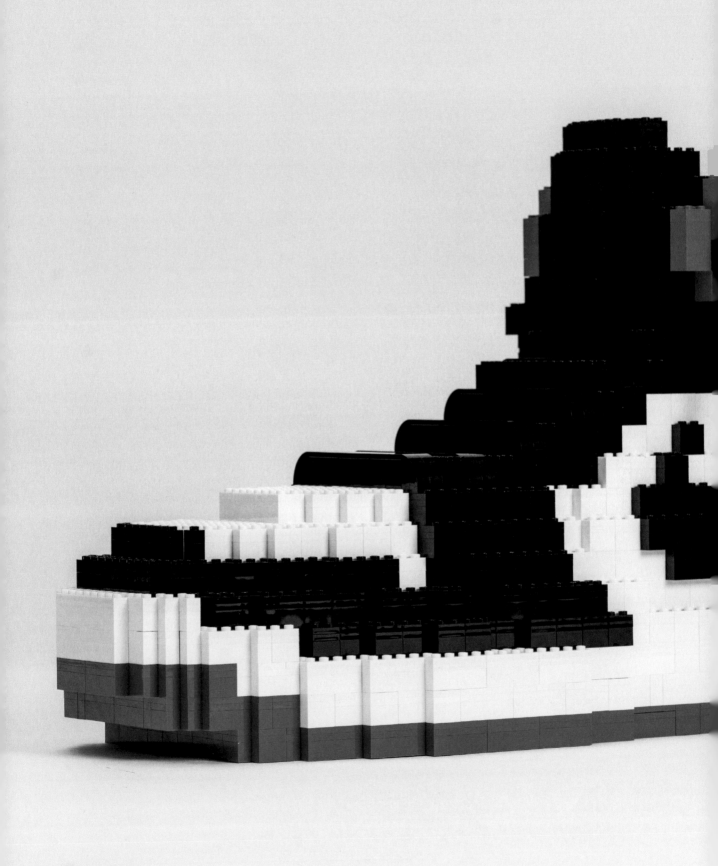

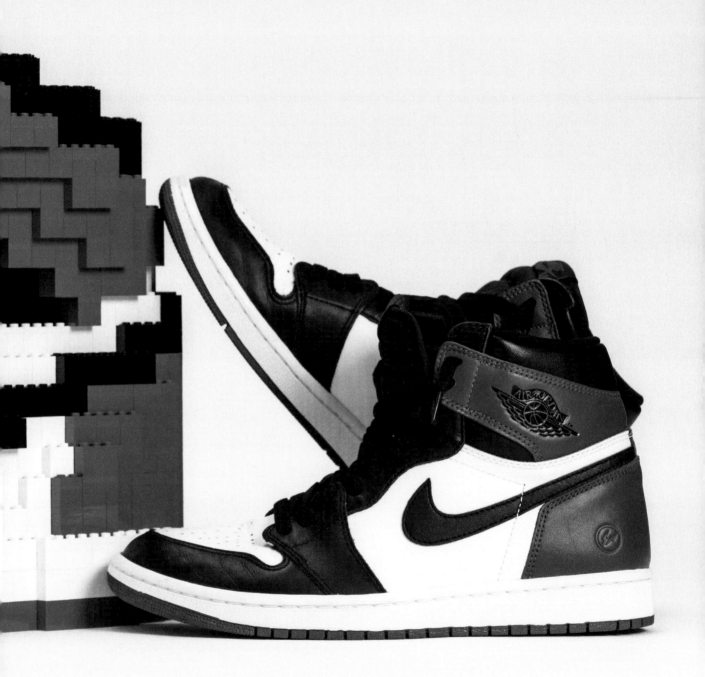

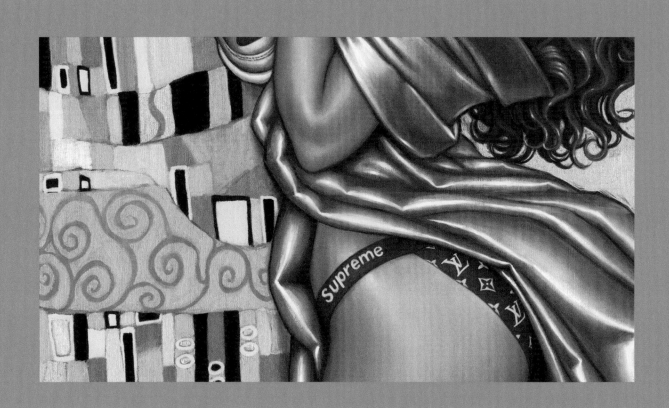

MIMI YOON

MIMI
YOON

LOS ANGELES, CA

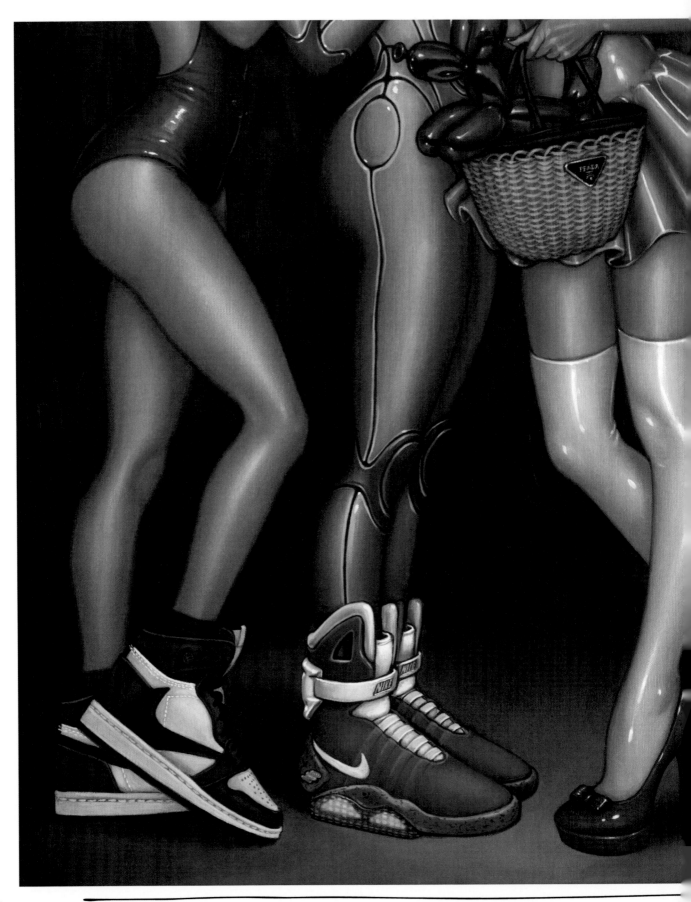

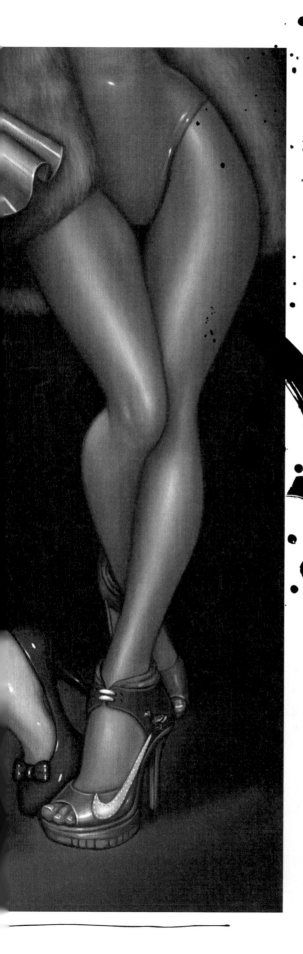

California illustrator and painter Mimi Yoon creates a world in which women hold all the power. Her subjects carry an archetypal cognizance, and Yoon's ability to play with divine feminine energy seems boundless. She bestows on her women the superheroic force to stand in their sensual power rather than using it as their only power.

Being born and partially raised in South Korea, her paintings carry a blend of Eastern and Western culture. A byproduct of a strict Catholic upbringing were deep feelings of suppression that Yoon now feels she's able to release in her works. The enchanting quality given to her female subjects is a tool to point out the seduction of our society's consumerism. Just as one falls in love with the shapes, curves, and colors of a new Jordan, one can feel similarly while gazing at the goddess-like hourglass shape of a woman.

Some of Yoon's works pay direct homage to several artists, trends, social agendas, and more. In "You Dropped the Bomb on Me" Yoon plays off of Austrian painter Gustav Klimt's most famous painting "The Kiss." In Yoon's version, the kissing couple are backdropped by graffiti rather than gold. The female subject still gets this "bomb" of a kiss dropped on her by a hulking male figure, but instead of being entirely sheathed and covered in blankets, she's confidently showing off a pair of Supreme x Louis Vuitton panties and rocking a men's pair of Air Jordan 1s. When comparing the two works side by side it's easy to see what Yoon is differentiating metaphorically and socially here: women no longer need to be seen as diminutive and submissive. In this rendition a woman can find sexual surrender in a simple kiss but her power is still completely hers.

WWW.MIMIYOON.VIEWBOOK.COM

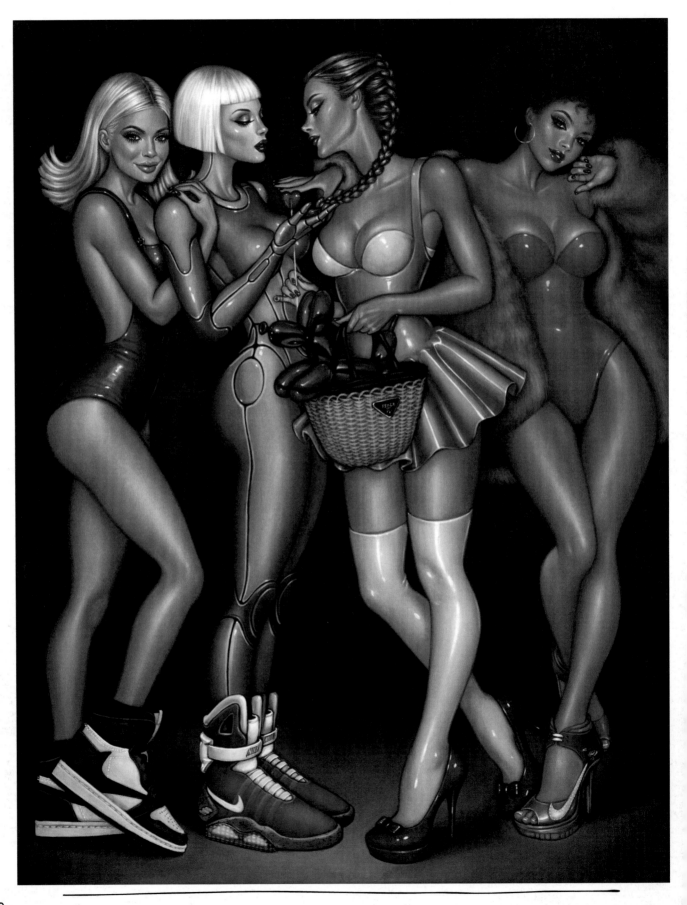

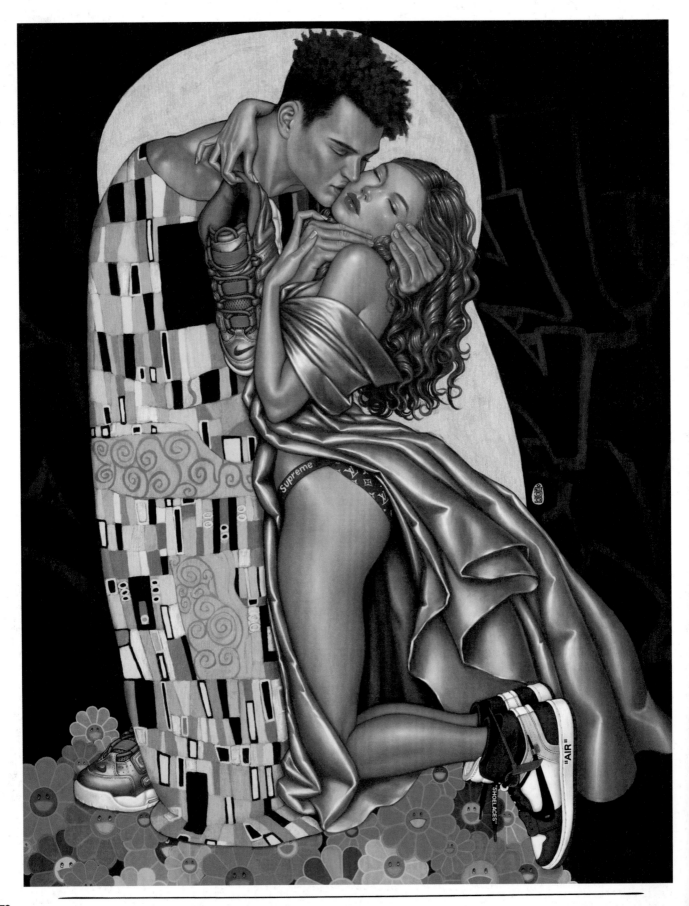

172

"WHEN I FIRST STARTED TO PAINT, EXPRESSING SUBTLE EMOTIONS, I WAS RELEASING THE EMOTIONS, I WAS TAUGHT TO SUPPRESS."

– MIMI YOON

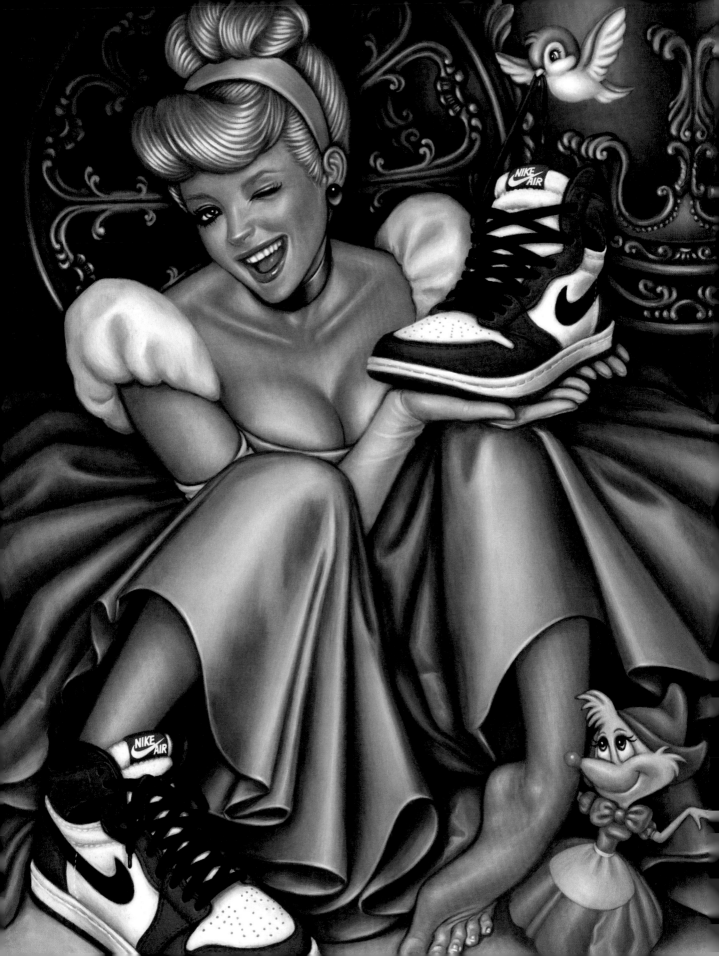

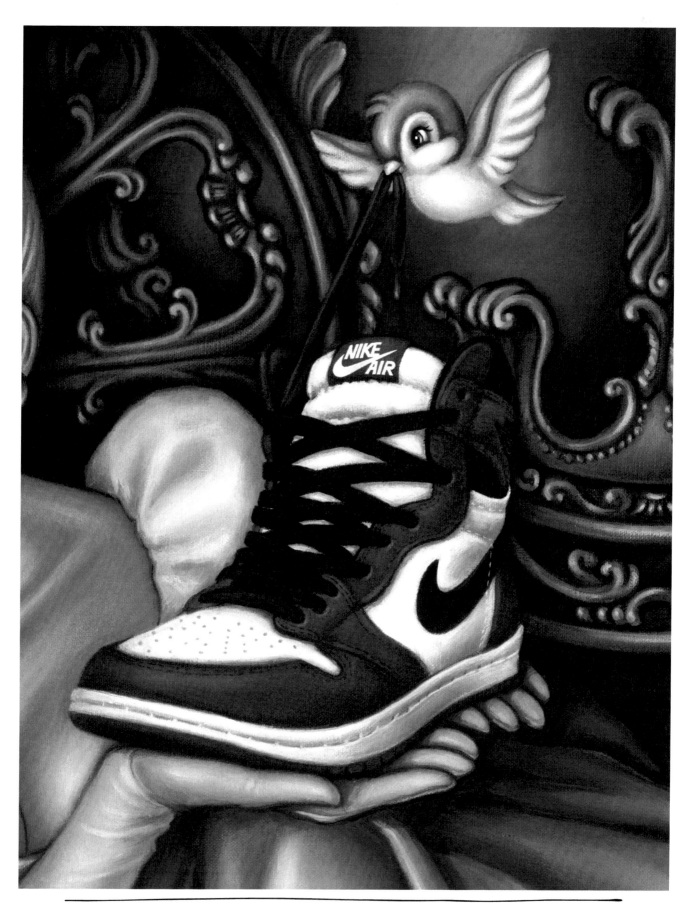

snkrINC
WORK IN PROGRESS

Editor
Ivan Dudynsky
Creative Director
Buzz Chatman
Art Director
Alec DeMarco

Cover Design
Christophe Roberts

Foreword
Jeff Staple

Curators
Ivan Dudynsky
John Colombo
Danny Holcom

Writers
Buzz Chatman
Amanda Scott Soroka

Project Managers
Michael Dagnery
Mike Welch
Jack Schulze

Photographers
Ivan Dudynsky
Frankie Batista
Frankie Coto
Gary Lockwood

Logo
Frank Kirstein

VOL. 1

THE ART OF SNEAKERS

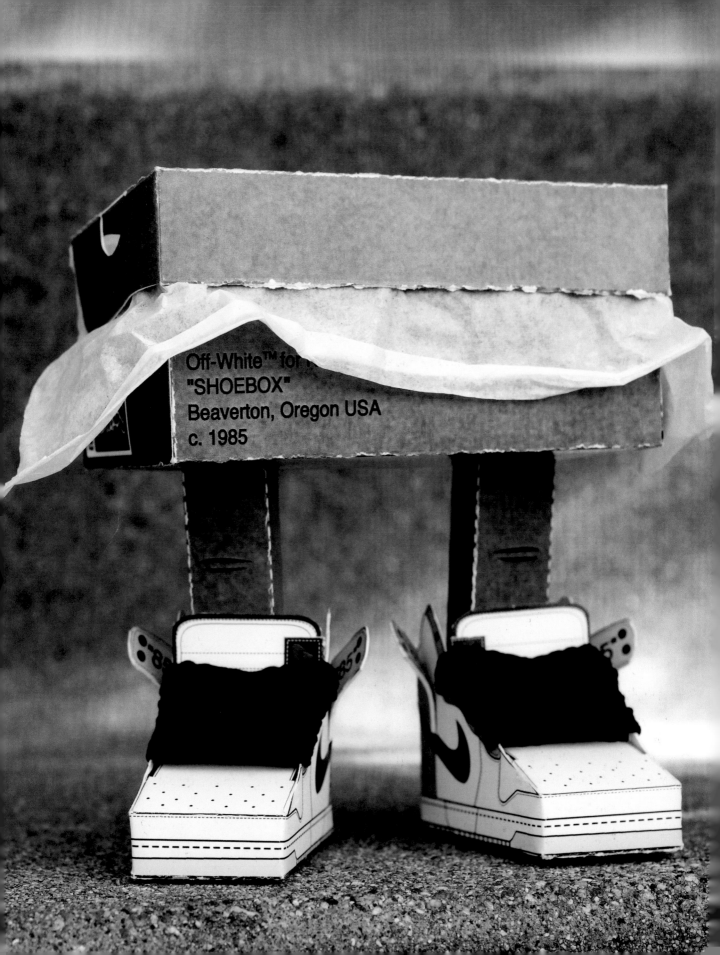

TAOS VOL 1 SPECIAL THANKS

snkrINC / Ronin Dudynsky / Audrey Morrissey / Dermot McCormack / Jeff Staple / David Garrett / Jayson Belt / Don Meek / Stephanie Wilmers / Bri Yip / Lauren Matic / Frank Kirstein / Marni Colon / Heather Blair / Mollie Bloom / Beija Velez / Hiroshi Fujiwara / DJ Clark Kent / Sean Wotherspoon / Bobito Garcia / Zach Schlemmer / Steezus Christ / Shoe Wolf / John Geiger / Nigo / KAWS / Sneaker Steve / Patino / Ron Holden / Melita Curphy / Wes Armstrong / Gary Hughes / Andre "Dre" Ljustina / Drumma Boy / Franalations / Statik Selektah / Afrokix / Kenyon Martin / Freehand Profit / Brandan Edler / Zero / Complex / OptimistLA / Extra Butter / Sneakers N Stuff / SportieLA / Round Two / NTWRK / Widen + Kennedy / David & Goliath / Kith / Undefeated / Supreme / Nike / Adidas / Puma / Fila / Reebok / Vans / Greats / Project Blitz / GOAT / Stock X / Stadium Goods / The Hundreds / DOPE / Defer / Alec DeMarco / Atmos / Dunk X Change / Nice Kicks / Ales Grey / Android Homme / Agenda / Sneakernews / YouTube / Vimeo / Facebook / Instagram / Bape / Bait Me / Flight Club / Sneaker Freaker / Shoe Surgeon / Romy Samuels / Sophia Chang / Sheela Awe / Nai Vasha / Janae Roubleau / Soraya YD / Suzy G Styles / Hannah Radd / Tiffany Beers / Revolt Crew / Salim Mitha / Ian Doody / Ross Hiatt / Shoe Wolf / Yu Ming / Simone Moore Remington / Racks / Matt Halfhill / Josh Luber / Aaron Levant / Chester Cantaoi / Wanton Davis / Kevin Egle / Chris Elsner / Vanja Primorac / Farnaz Taher / Greg Payton / Danielle Davis / Dean Lee / Matt Jacobson / Eric Phan / Nelson Diaz / Bernie Gross / Nils Arand / Tinker Hatfield / Andy Schuon / Mark David / Edward Elliot / JY Kim / KJ McCann / Will Bolt / King Masa / Chris Roth / Eric Avar / Theresa Tran / Darla Vaughn / Doug Johnson / Steve Drobny / Joe Tremaine / Jackie Sleight / Julie McDonald / Theresa Taylor / Tony Selznick / The Dudynskys & Morrisseys / Rich Antonelli / Tom Flanagan / Janae Twisselman / Daniel Cherry III / Nick Crooks / Carren Morris / Sean Maher / Devon Woodruff / Matt Hillman / Craig Cohen / Will Luckman / Jose Sanchez & Crew / Sam Wick / Evan Warner / Lance Klein / Detroit Bruce / Johannes Kastner / Thomas Grabner / Brandon Rochon / Stella Na / Pegah Ghannadian / Bastien Frediani / Gene Dibble / WME / UTA / CAA / ICM / Evolution / E3 / Kicksperience / Agenda / NTWRK / Sneakercon / Barclays Center / Gary V / Usher / Pharrell / Ron LeFette / Ryan Tedder / Travis Scott / Kanye West / Adam Levine / Mark Burnett / Barry Poznick / Victor Cruz / Taye Diggs / Will.i.AM / Virgil Abloh / Raf Simmons / Sean "Puff" Combs / Stephen "tWitch" Boss / Serena Williams / Phil Knight / Run DMC / Spike Lee / Stan Smith / Pele / Kobe Bryant / Michael Jordan / King Masa / Matt Powers / Jim Paratore

And a special thanks to everyone who bought this book and supported these incredible artists. We hope that this is just the start and that The Art Of Sneakers: Volume Five Is filled with inspired art from the kids reading and scanning these pages today. One Love. iD